MANDALA FOR CRUSOE

FRANCESCO CLEMENTE

All works © Francesco Clemente 2012
Publication © Blain|Southern 2012

PUBLISHED BY

Blain|Southern
4 Hanover Square, London, W1S 1BP
www.blainsouthern.com

EDITED BY

Louisa Elderton

ART DIRECTION & DESIGN

Inventory Studio, London

PHOTOGRAPHY

Eric Vigil, New York ·
Matthew Hollow, London

PRINTED BY

Lecturis, Eindhoven

ISBN

978-0-9569904-6-4

THANK YOU

Alba Clemente, Isabel Barber
Louisa Elderton, Mario Codognato
Norman Rosenthal, Ricardo Kugelmas

With this new series of fourteen extraordinary paintings conceived specifically for the Hanover Square gallery, Blain|Southern is exceptionally proud to present the first exhibition of Francesco Clemente's work in London for seven years. Throughout his career as an artist, Clemente has explored, developed and continually returned to particular themes, obsessions, techniques and formats. This most-recent body of work exemplifies the unpredictable interior monologue or cadent individual stream of consciousness that also characterises the apex and origins of Clemente's practice.

Dense with the artist's inimitable language, these new paintings represent a further step in his outstanding artistic oeuvre. They simultaneously contain and renew his visual and conceptual vocabulary, which could be described as being magnetically fragmented, moving between opposites to produce an unprecedented idiom. There is a dialogue between ancient myth and contemporary life, abstraction and narration, masculinity and femininity, autobiography and universality, animal and human, body and mind — to name but a few.

The power of his art lies in its utilisation of visual metaphor — in its rhetorical ability to express the sensitivity and the sensuality of the body, and the essence of animal instinct, of exorcism, so intrinsic to his mask-like faces. The eternal dimension of mythology is coalesced with these to constitute an individual vision that sets off a chain reaction of references and associations. The ultimate result is that meaning is not fixed; instead, reality and other diverse contexts are superimposed upon one another and meaning oscillates, as if slipping into the delicate cracks between mosaic tesserae.

Through the deconstruction of an artificial and illusory whole, the clarity of Clemente's vision is coherent with the ways in which we perceive ourselves through sight and touch, and indeed all of the senses — we operate through a heterogeneous set of points of view, angulations, relationships and diverse phenomena. As exemplified in his beautiful paintings, a fragmented vision of reality presupposes that human life has two basic, coexistent poles; one is utopian and sees the world as a continually developing construction, with the possibility of finite unity; one is tragic and sees contemporary life as being impotent, forever cut off from relationships that might reconcile the ego and the other.

Harry Blain, Graham Southern and I are indebted to a great number of people who have assisted in the preparation of this exhibition and the accompanying publication, which has been produced by Inventory Studio, London.

We are extremely grateful to Norman Rosenthal for his illuminating essay on these new works. Collaborating on a number of exhibitions through the years, Clemente and Rosenthal have come a long way together. Included among their many projects are historical exhibitions at the Royal Academy such as the legendary *New Spirit in Painting*, which was also co-curated by Nicholas Serota and Christos Joachimides in 1981 and celebrated the rebirth of painting on an international scale, and *Italian Art in the Twentieth Century*, 1989, which consecrated Clemente and marked him as being among the most important artists of his generation.

Thanks also to my colleague Louisa Elderton, who has managed every step of the exhibition and editorial of this publication with the greatest of expertise and perseverance; and to Mark Inglefield and Eloise Maxwell for their invaluable attentiveness and suggestions.

I hardly know how to thank Ricardo Kugelmas, without whom it would not have been possible to mount the exhibition and produce the publication. And of course, as always, I am indebted to Alba, Francesco's wife, for her inestimable hospitality and suggestions during these months of preparation for the exhibition.

CRUSOE MEETS CLEMENTE

NORMAN ROSENTHAL

In 1980, a young artist from Naples — a son of its erstwhile Queen Parthenope, mythological mermaid founder of this beautifully chaotic city south of Rome — made his way to the New Rome that had grown up so recently on the Western side of the Atlantic Ocean. He had already become a master of that near-lost, uncommon art of Fresco painting. Equally a direct descendent of the unnamed Pompeian painter of the *House of Mysteries*, though through a different line, he too is related in spirit to those great masters who decorated the great Neapolitan Certosa of San Martino in the seventeenth century. Arriving in New York, Francesco Clemente was soon to find himself feted for his extraordinary painterly and graphic talents — and his compelling good looks. Soon he was invited to make joint works on large canvases with two celebrity artists of the 'New World Culture'. These were Andy Warhol and Jean-Michel Basquiat, artists who at a certain level seemed to have less old culture to their name than even Brillo boxes and Candy Darling, or indeed the crass graffiti that covered every single subway train in the city, from front to back carriage (in the meantime all of the trains have been washed clean).

What on earth was this young European artist looking for in New York? He had already been to India with Alighiero Boetti, resultantly carrying not only the baggage of European but now also magnificent Indian civilisations from past millennia. Clemente, who among his many qualities one can describe as being a cultural carnivore of the highest order, was even then finding beauty and new graphic ways of expression that had much to do with the immediate manifold visual and literary experience surrounding him. His work represents a permanent dialogue between his own subjective self and the external world, both old and new. Throughout his oeuvre he shows himself to be an artist who continually questions and, more importantly, celebrates the role of all bodily functions — whether in the mind, the imagination or the inevitable imperatives of human orifices and protrusions.

This all occurs with a loving sympathy that appeals to our visual and also literary sensibilities. Living in New York and rapidly absorbing Anglo-Saxon linguistic culture, he was soon to count among his heroes and indeed personal friends those legends of the Beat Generation American poets, Allen Ginsberg, William Burroughs and others. He felt at home with them, and his paintings are full of allusions to authors, both modern and ancient. The latter include those anonymous writers of Sanskrit who composed the extraordinary and heroic texts the *Ramayana* and the *Mahabharata*. Equally, there is the author of that work which heralded the European Renaissance, the *Divine Comedy*, and his great Persian contemporary, the poet Hafiz—later to be celebrated by Goethe in his *West-Eastern Divan*. Like Clemente himself today, these poets from then and now celebrate the intoxicating powers of love and sex. But the extent to which the Scottish poet Thomas Carlyle — the subject of one of the paintings in this exhibition, who translated into English many of the works of Goethe — was fully engaged in the sensuality of that which he was trying to mediate is questionable. He seems perhaps closer to the world of Shakespeare and Milton than that of the confused, romantic German Doctor Faust. Nor for that matter would Carlyle, were he able to fast-forward in time, find himself any more able to happily wallow in the sensual yet strangely puritan American worlds of authors such as Walt Whitman or Frank O'Hara.

Clemente usually works in great suites of oils or watercolours. In the latter medium he is surely the master of his age, just as he is in the art of fresco. Indeed, his oil paintings at their best always have the beautifully thin and exposed quality of those other media. However, for all the skills of earlier times that he has mastered and holds dear, he is a Modern — a true artist of his time. In his strategy of modern-ising the civilisations of ancient worlds, he is different but no less ambitious than

Joseph Beuys. In their art and actions, both are conscious of the migratory cultures of Eurasia. In the case of Clemente the movement is in both directions, from West to East, East to West and across oceans.

In this new group of paintings, christened *Mandala for Crusoe*, fourteen large canvases have subjects that allude to everything from Carlyle's high Victorian culture to the American film actress and model Chloë Sevigny — she, with an image characterised by a transgressive nuance and who first came to fame in *Kids*, the cult 1995 movie by Larry Clark. Then there is the legendary Candy Darling who teams up with Chloë in the imagined scene depicted by Clemente. Which side of the cultural divide is turning in their grave, Carlyle or Candy? Maybe we can identify them all in the strange dreamlike painting *La femme fontaine*, where endlessly sleeping or possibly dead male and female bodies float and intertwine within two breast-like shapes. In the outside world — or is it perhaps the inner — we see what look like strings of DNA floating randomly above in another sphere. It is a Dantesque vision, a *Malebolge*, a ditch of evil, that is perhaps echoed in another painting, *The backpacker*. Here, in the manner of Eadweard Muybridge, that strange Anglo-American photographer and contemporary of Thomas Eakins, this figure seems to march over some terrible cliff towards infinity or nowhere.

To analyse Francesco Clemente's painting is inevitably to look into the world of modern dreams and desires. Whether such dreams hail from subjective experience or indeed from study is a big question. Perhaps the answer is that they come from both spheres. We look with pleasure at his images, and it is inevitable that we describe his paintings as 'images' or as 'visualised words' for all their beautiful colour and graphic qualities. They command attention because of the poetic juxtaposition of actual things we behold. They demand a sympathetic skill to decipher or decode them, though they are equally beautiful if left forever dreamlike and ambiguous. What are we, for example, to make of a painting such as *Indigo's child* — a black male horse standing against a night sky, ejaculating riches from both its mouth and sexual organ over the body of a Reclining Venus? Are we to recall the Danae of Titian, in which Zeus impregnates the imprisoned girl with that famous shower of gold? Are we prompted by the artist to imagine the horse as another form taken by Zeus? To the best of our ancient knowledge, Zeus never took the shape of a horse, but there is no reason why this should not occur within the artist's dream. Nor should birth itself not be provoked, as witnessed in the painting *Chasing the star*. Here, our Zeus-like horse delivers a fully grown male from within its body, aided by the Danae who is locked up, not as in the old stories in the bronzed prison room of her father Acrisius, but within this horse's own grey-white body. We might invite Freud, with his ideas of personal wish fulfilment, to interpret these dreams, or Jung, with his greater emphasis on the collective consciousness as an aspect of cultural memory. Should we interpret the dream image/painting in terms of archetypal symbolism, or can we just allow our minds to meander according to our own memories and associations?

Those beguiled here by the avian images of Clemente are likely to remember those classical modernist paintings of birds in flight by Picasso and Braque, by Max Ernst and Magritte, all of them executed in the wake of Fascism and the Second World War. In the case of the first two, the birds were to become symbols of hope and peace; in the case of the two Surrealists the birds seem more threatening with their outstretched wings. One of Clemente's birds, *The sky on the wall*, is a large-scale reprise of one of Magritte's birds, suspended either upon or possibly even perceived through a wall. We might make out within the emblematic shape of the bird what seem to be cloud-like body parts floating in the sky. In another painting,

The dove of war — more reminiscent of Braque than Magritte — the bird's feathers seem to consist of outlined toy fighter jet planes, perhaps recalling Boetti as they fly amid a pink sky. The planes are like flocked birds moving chaotically in all directions.

There are also images here that recall ancient times and those extraordinary cultural links that bound both Greece and Ancient Rome — from the time of Alexander the Great to that of the Emperor Hadrian — with the Silk Routes and the Far East. Clemente may indeed have been to Afghanistan with Boetti in the 1970s, to that part of the world now torn asunder with ghastly strife; two millennia ago, however, this region known then as Bactria and Kush, was a world of high civilisation and a veritable cross-roads between East and West. Recent French archaeology demonstrates that human activity here stretches back eight thousand years even before the Christian era. But in the centuries before and after the time of Christ, northern Indian subcontinent cities of huge sophistication gave rise to the Gandhara civilisation, which Clemente celebrates in a painting he calls *Gandhara dream*. Roman columns, which formed part of those now lost Afghan cities, surmount skulls which themselves are surmounted by egg-shaped heads, giving the columns a priestly quality. We now know that in those distant days the world of Pompeii and Rome had astonishing links with India. Clemente summons the Indo-European linguistic dream that is central to his own sophisticated private mythology. In another image, Clemente imagines Noah and his ark of animals on Mount Ararat — which is after all in Anatolia — floating on a sea of Sanskrit. Noah, like Robison Crusoe on his desert island, was indeed a remarkable and lucky survivor. Mythology, literature, dream and history are not that far apart, as the artist demonstrates.

There are such various ways of approaching the past: as scientists or historians it is possible to present definite conclusions via archaeology and surviving documents and objects. Equally legitimately, we might dream of images of history and myth, intertwining them with contemporary culture and allowing them to infuse one another. This is something that has been done by artists from ancient times to the present. Think of Mantegna's *Triumph of Caesar* cycle, now at Hampton Court. Such intertwining allows the viewer space in which to reflect and, possibly, to respond. What, after all, is a mandala if not a tool for memory; a map that demonstrates the possibility of finding absolute spiritual attainment through the representation of a self within a larger universe; an infinite space versus interior space, macrocosm versus microcosm?

In Clemente's new and spectacular mandala paintings, *Newspaper mandala* and *Sand bites mandala* (a pun on the 'sound bite', since Tibetan mandalas are often made with coloured sand), he places at the very centre of both images two 'modern' men where there might normally be representations of a Buddha or possibly an abstract infinite space. One of these new Buddhas reads a newspaper, the other, an even more contemporary figure, is perhaps texting into the world on a mobile handset. Is this the new path to Nirvana? These mandala paintings still have, as we contemplate them, the quality of Oriental Eastern carpets. Such grand carpets were always meant to recall exotic, even magical gardens. They represent places in which to abandon the self as though in a dream. Contemporary information — easy information — is perhaps becoming a place in which to relinquish the self in the virtual infinite space of a new Nirvana. This effect of losing the self is surely the goal of all artistic endeavour; the product too of listening to music, reading literature and contemplating painting. The legendary Khosrau Carpet, made for the eponymous and all powerful sixth century Sassanian emperor, was indeed able to defy the harsh realities of winter through the permanent illusion of paradise and the miracle of the ever-returning spring. This too is what Clemente's paintings achieve. They are

emblematic in the best sense, enabling us to be enveloped in a subjective world of the imagination in which we are absorbed by the artist's endlessly stimulating narratives.

Clemente exhorts us to take our experiences from everywhere. But as a Westerner he especially wishes us to absorb as much as we can from Eastern wisdom. Goethe was Thomas Carlyle's hero. In his final great book of poetry, the *West-Eastern Divan* (which Carlyle never translated), Goethe urges his reader as follows:

> North and West and South up-breaking!
> Thrones are shattering, Empires quaking;
> Fly thou to the untroubled East,
> There the patriarchs' air to taste!
> What with love and wine and song
> Chiser's fount will make thee young.

Chiser (usually known as *Khidr*) is a hugely revered angelic figure in Islamic cosmology. He is said sometimes to be a contemporary and friend of Moses and in other tales finds himself communicating closely with Abraham and even with Elijah — in rabbinical literature of the Middle Ages. After crossing the land of darkness he finds a spring that gives him eternal life. He even becomes a river god and a fountain spirit in certain parts of India, revered by Hindus as well as Muslims. Chiser was encountered by the great medieval traveller and adventurer Ibn Battuta who, between 1325 and 1354, roamed across huge swathes of Europe, Africa, Asia Minor and the Far East, including India and China, and was by all accounts the greatest world traveller outdoing even Marco Polo until the arrival of the nineteenth century and the age of steam. In our world of easy travel there is ever less pure cultural empathy between East and West; empathy is something that needs primarily to be based on wonderment, something which we also need in our dreams.

An artist for whom Francesco Clemente feels a special affinity is William Blake. Allen Ginsberg, in a book entitled *Your Reason and Blake's System* — published in the eighties as part of a series of tiny colourful volumes by Hanuman Books, an imprint of Clemente and friends in Madras, New York — described Blake's illustrated book *Urizen* as 'hard, tough and mental'. Ginsberg perceived the illustrations of Blake as having 'funny character and tremendous wit'. He says pertinently at the end of his small book that 'Blake was astonished by his own imagination'. One can be sure that the same is equally true of the artist of *Mandala for Crusoe*. He is indeed, in the best cultural sense, an astonishing and wide-eyed traveller of the world of his own imagination.

Norman Rosenthal
London, September 2012

MANDALA FOR CRUSOE

COLOUR PLATES

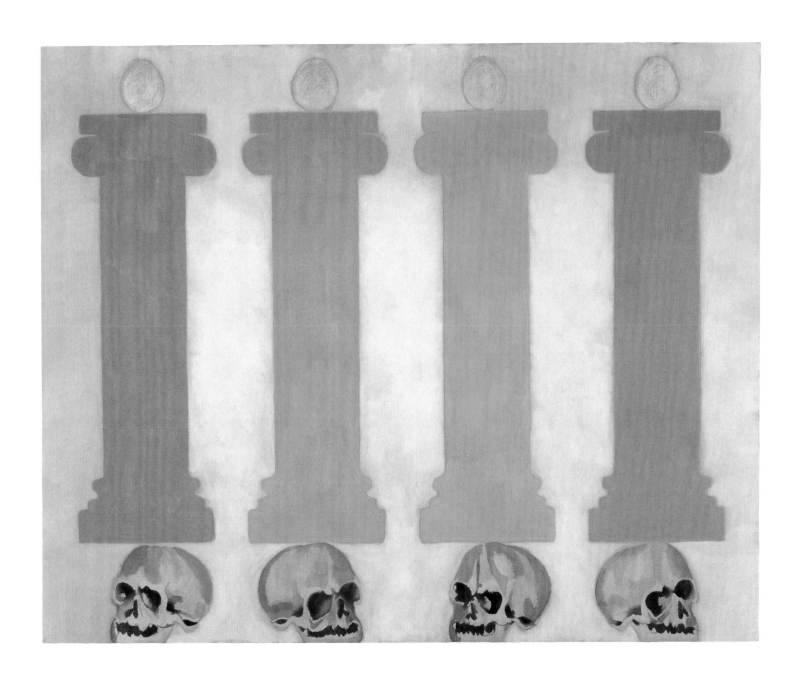

GANDHARA DREAM
2012, pigments on linen, 91 x 112 in

17

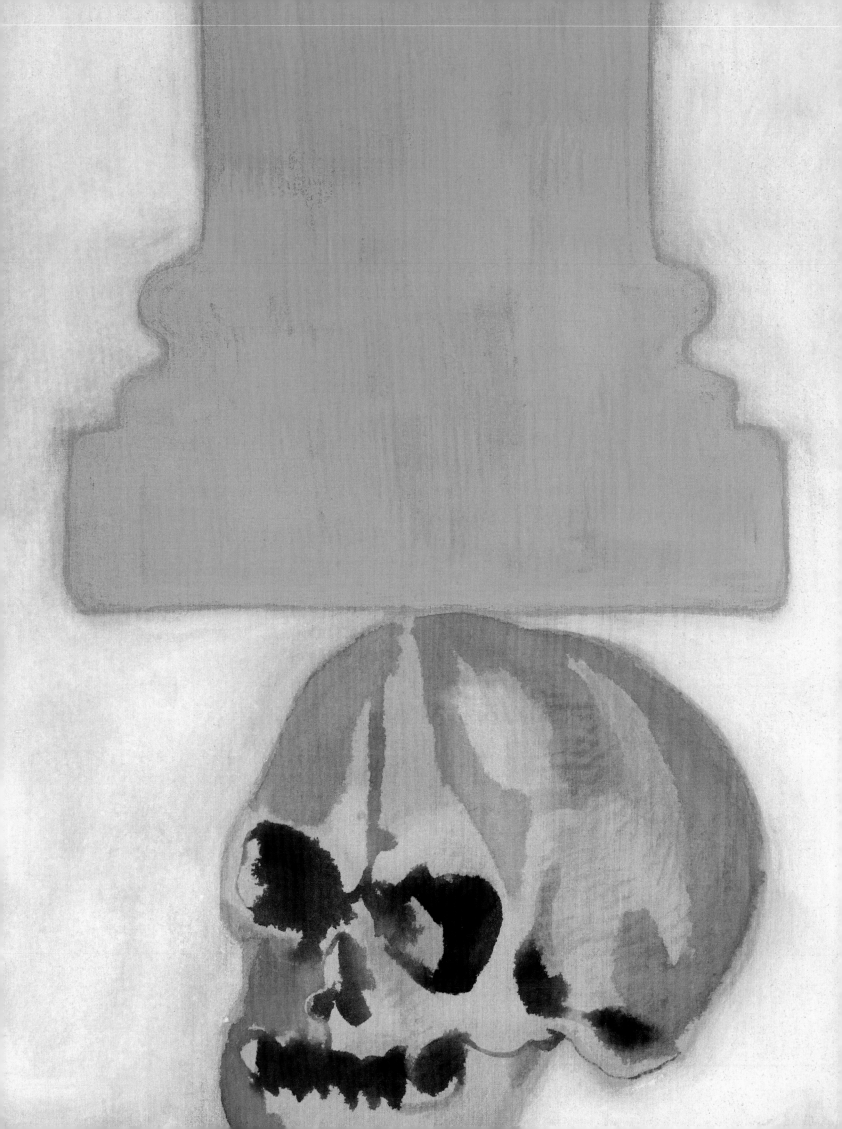

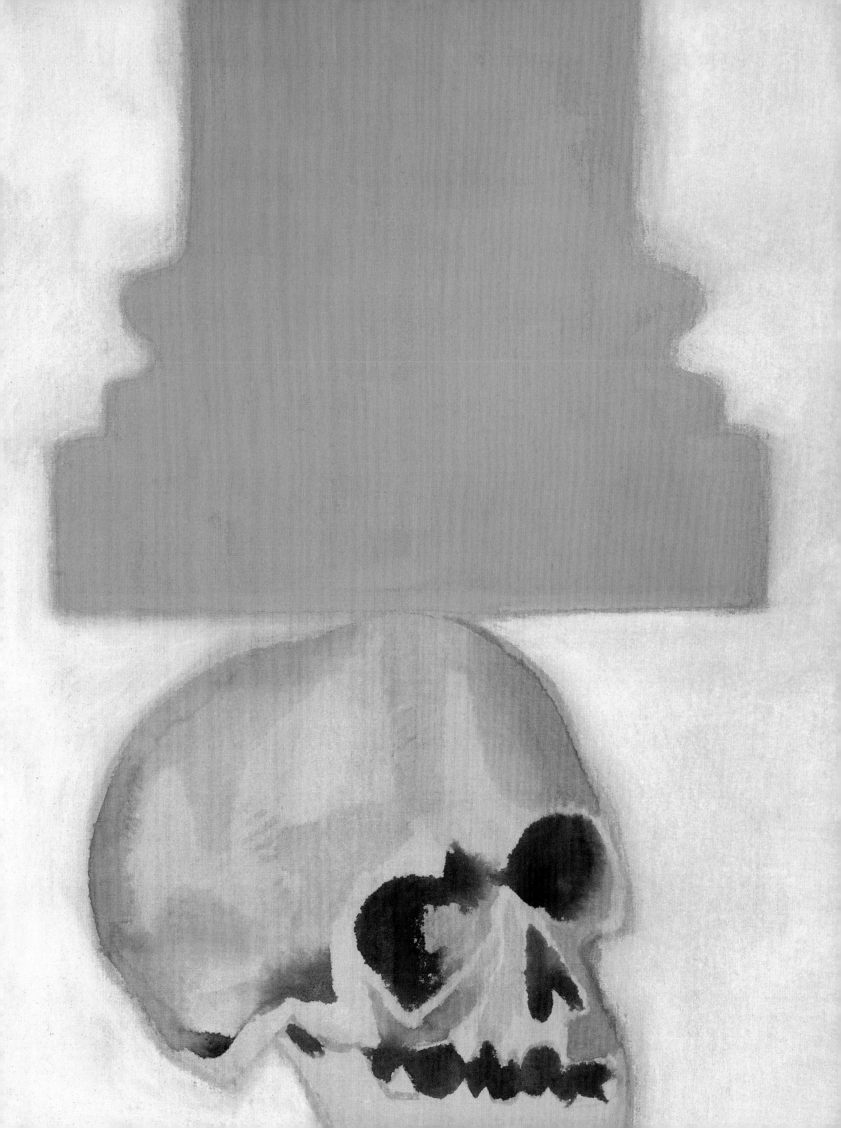

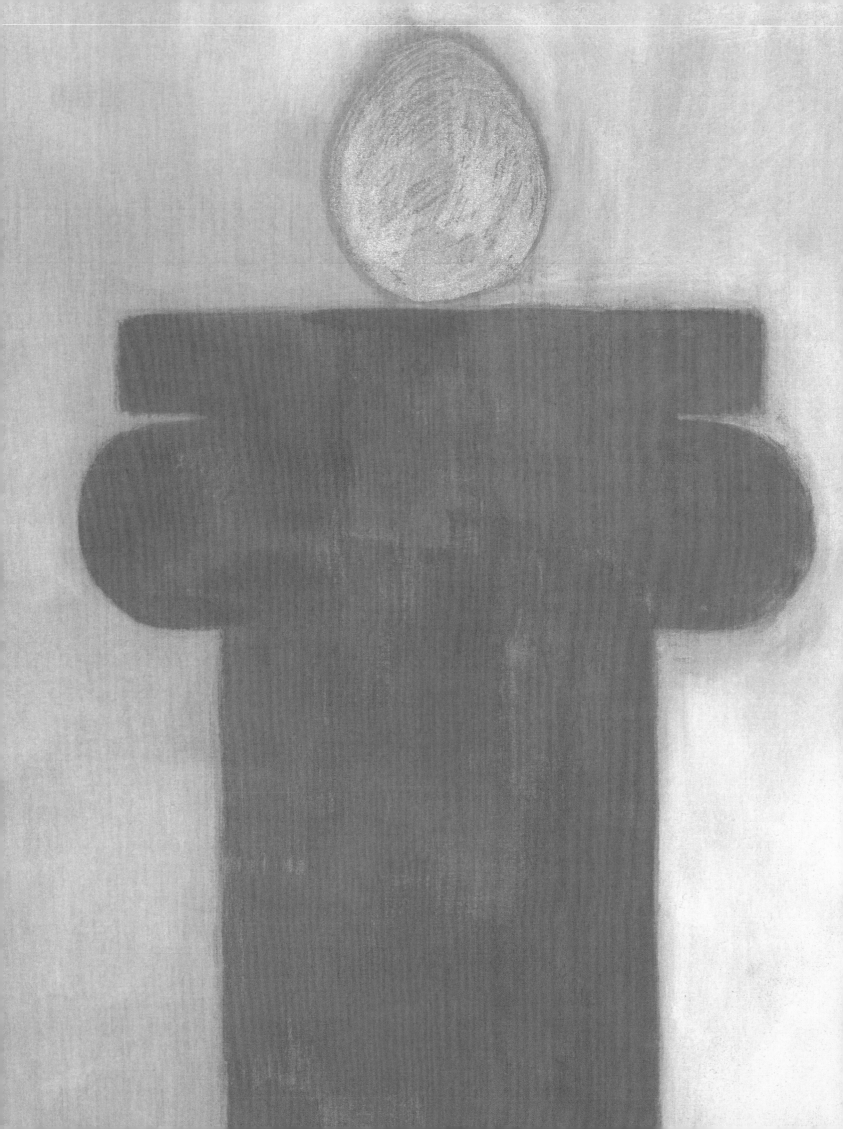

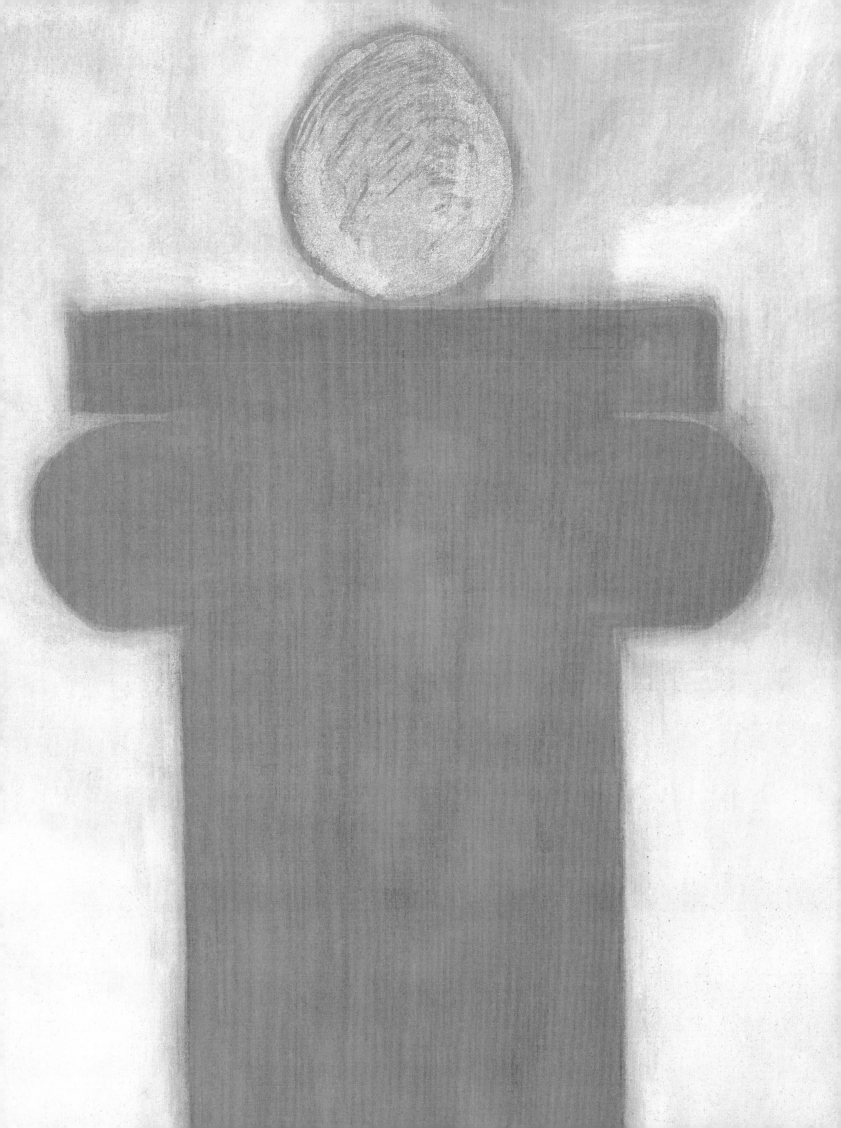

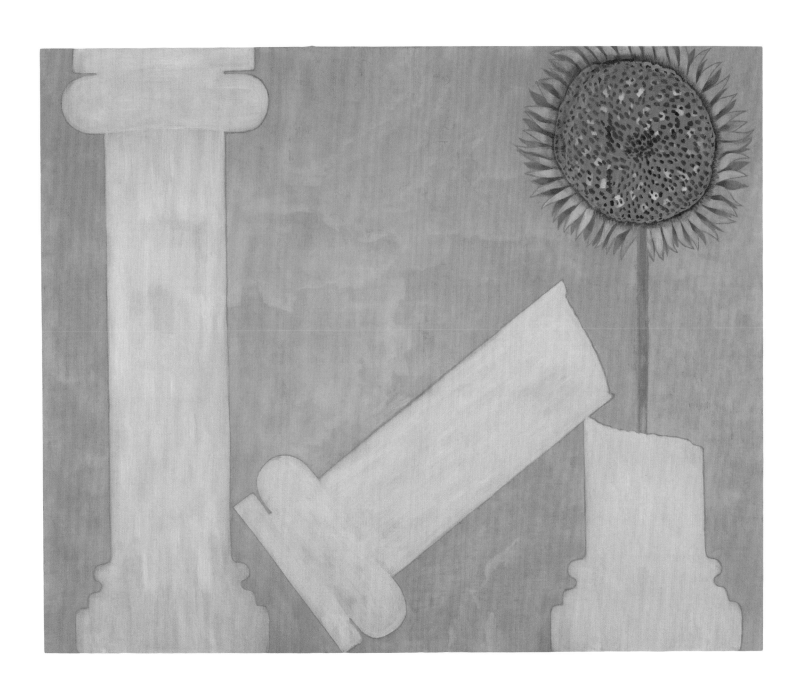

THE TRIUMPH OF THE SUNFLOWER
2012, pigments on linen, 91 x 112 in

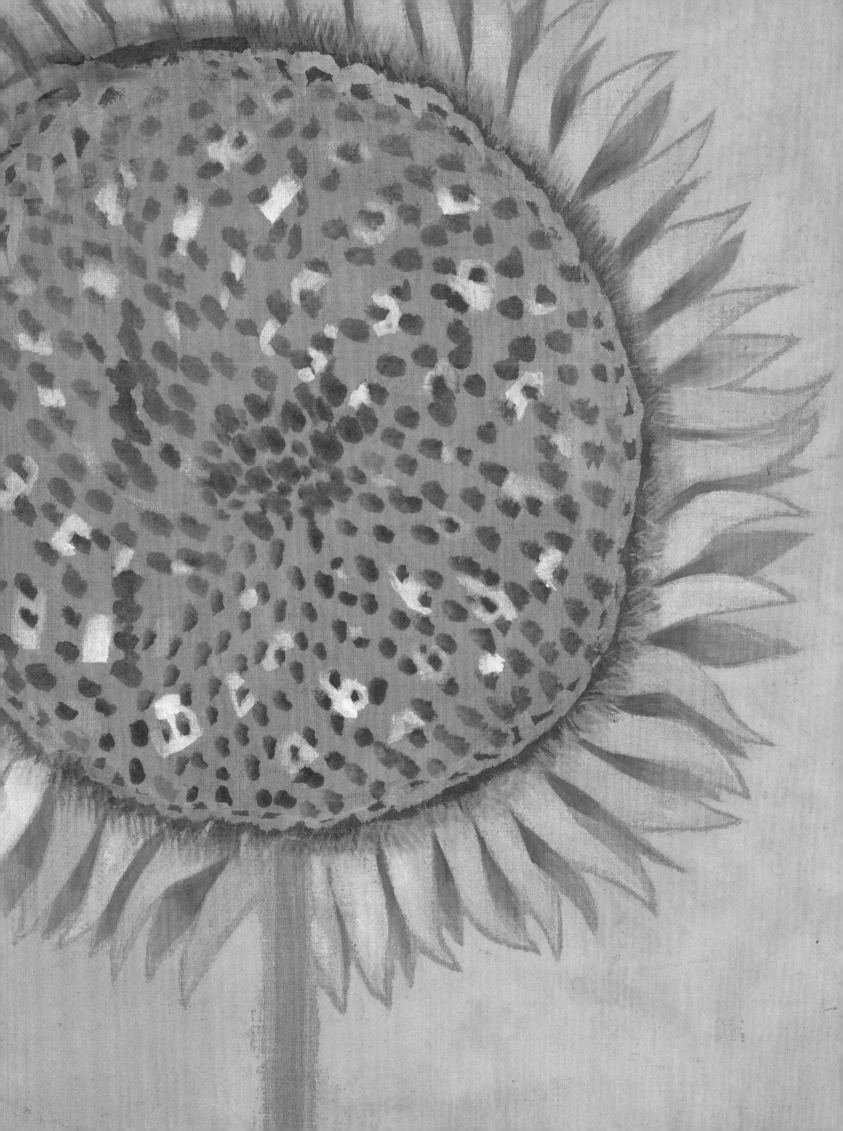

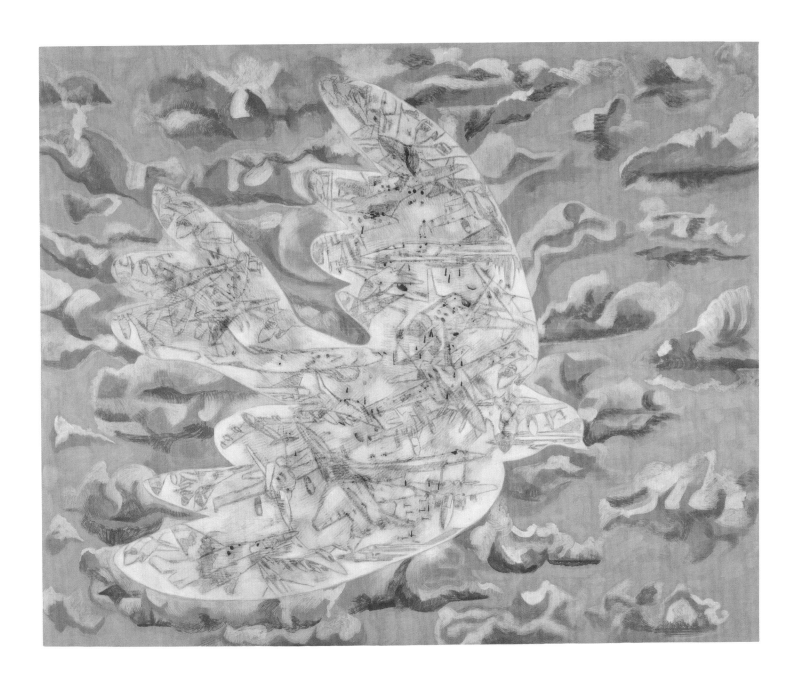

THE DOVE OF WAR
2012, pigments on linen, 91 x 112 in

29

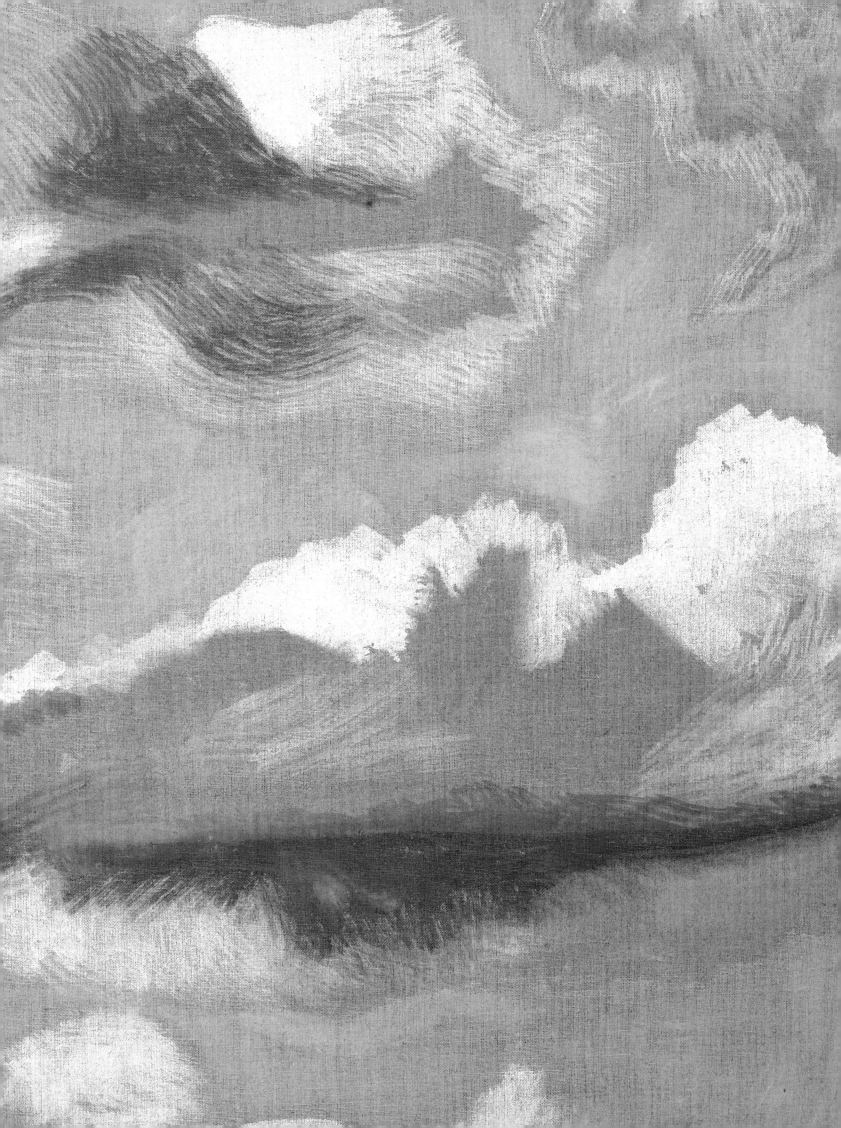

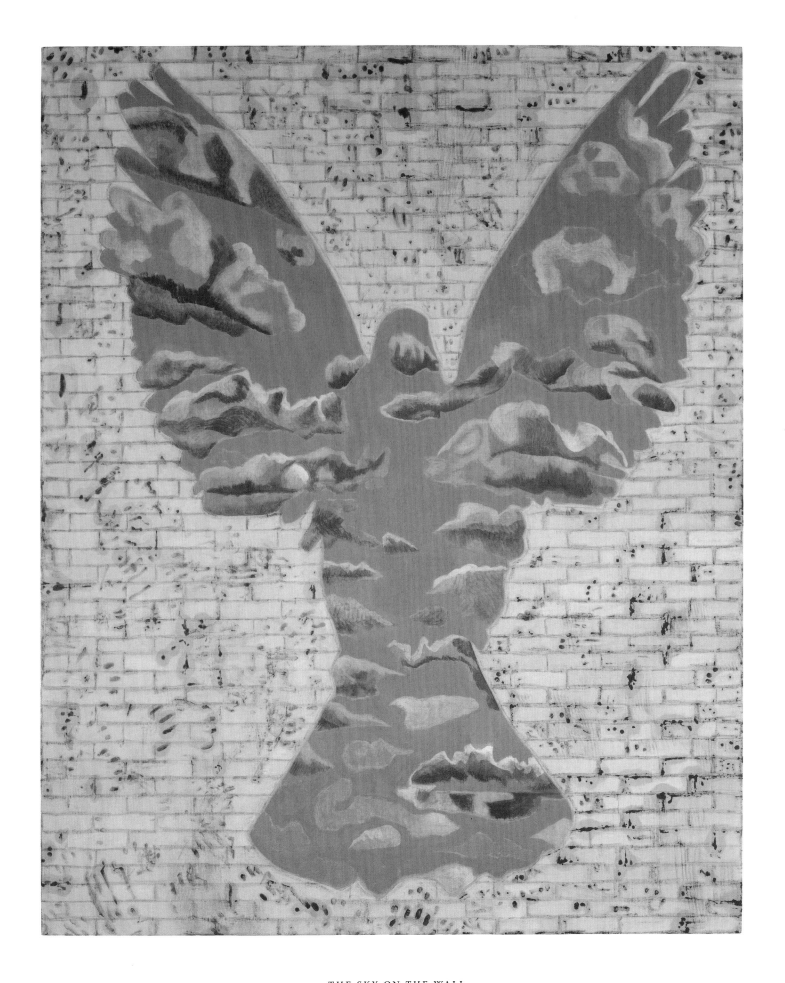

THE SKY ON THE WALL
2012, pigments on linen, 112 x 91 in

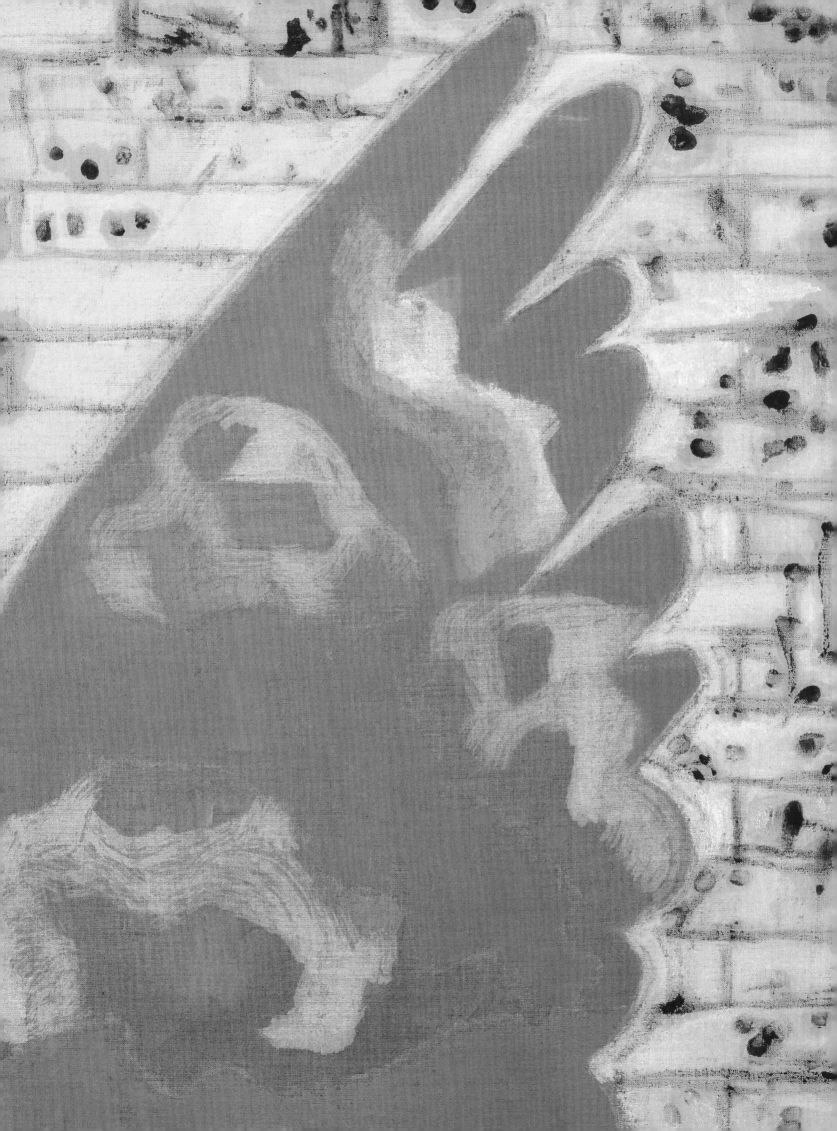

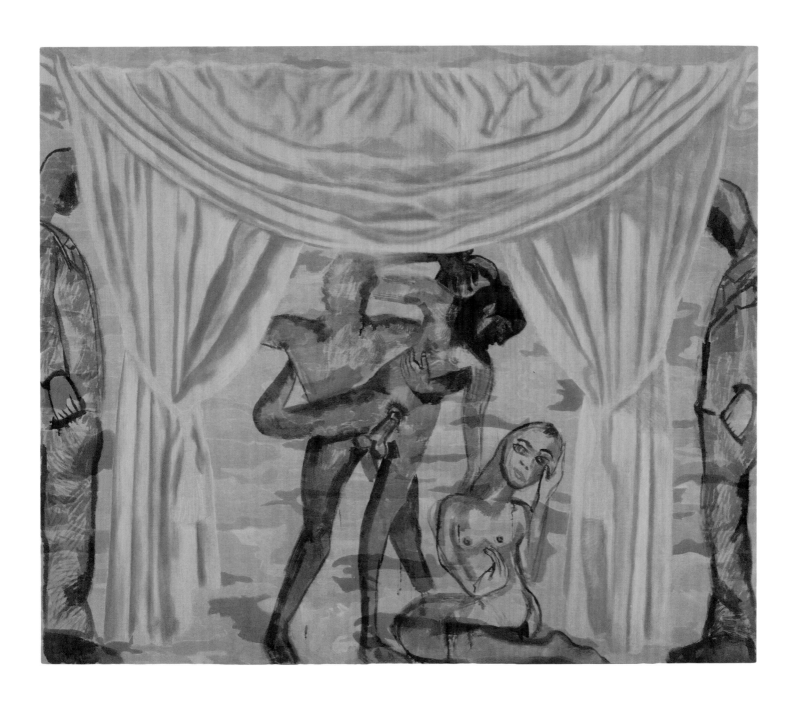

CANDY AND CHLOE AT THE GATE
2012, pigments on linen, 78 x 93 in

41

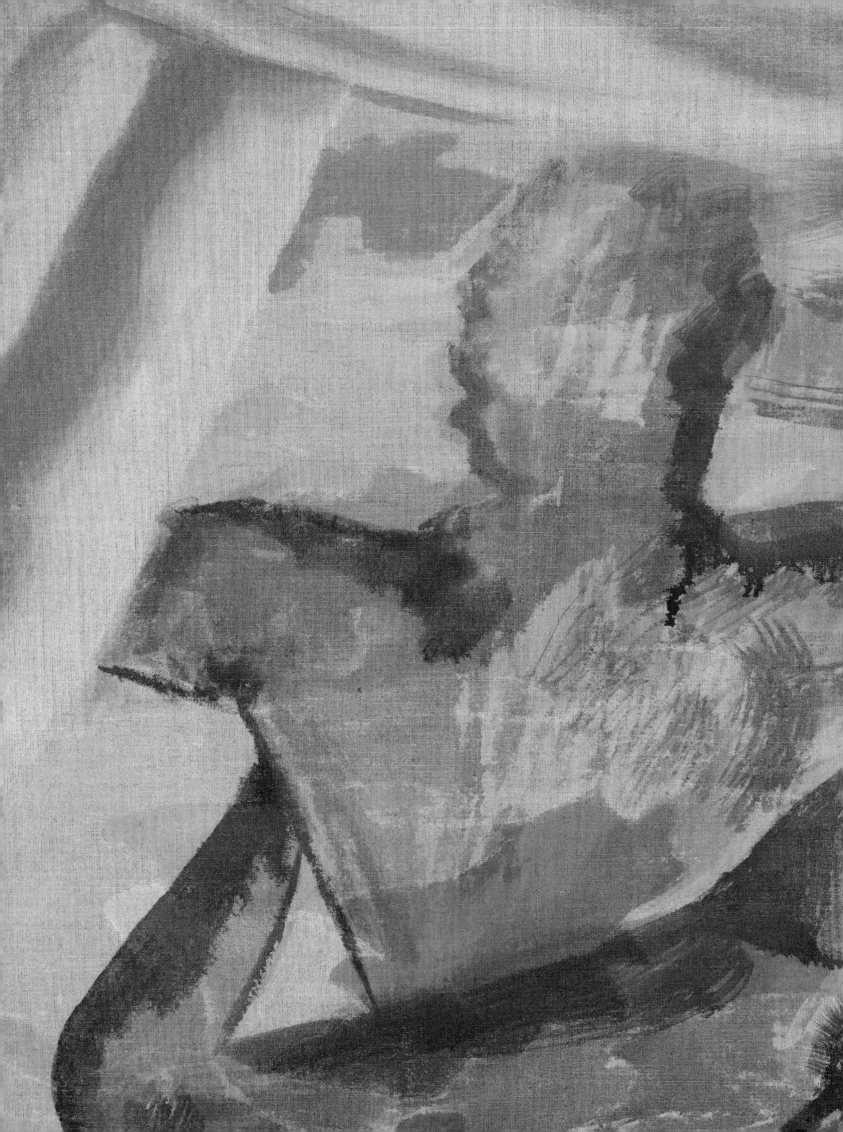

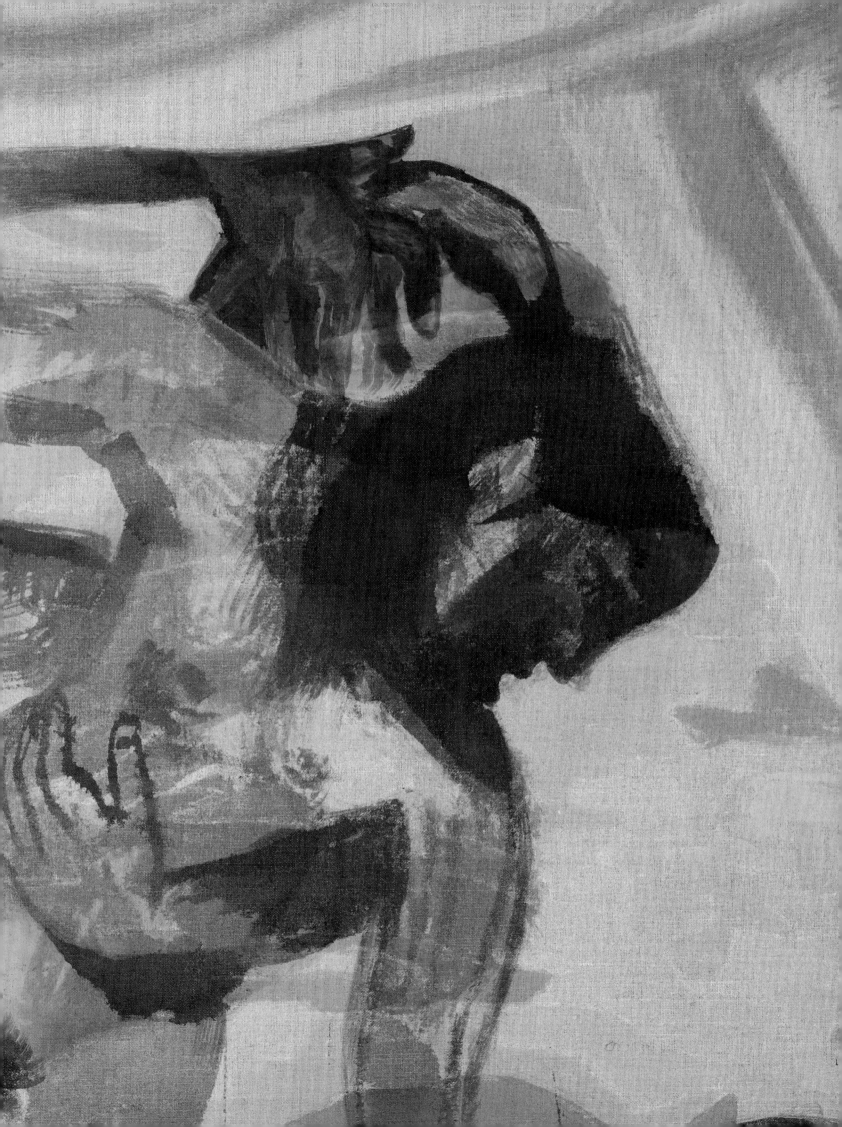

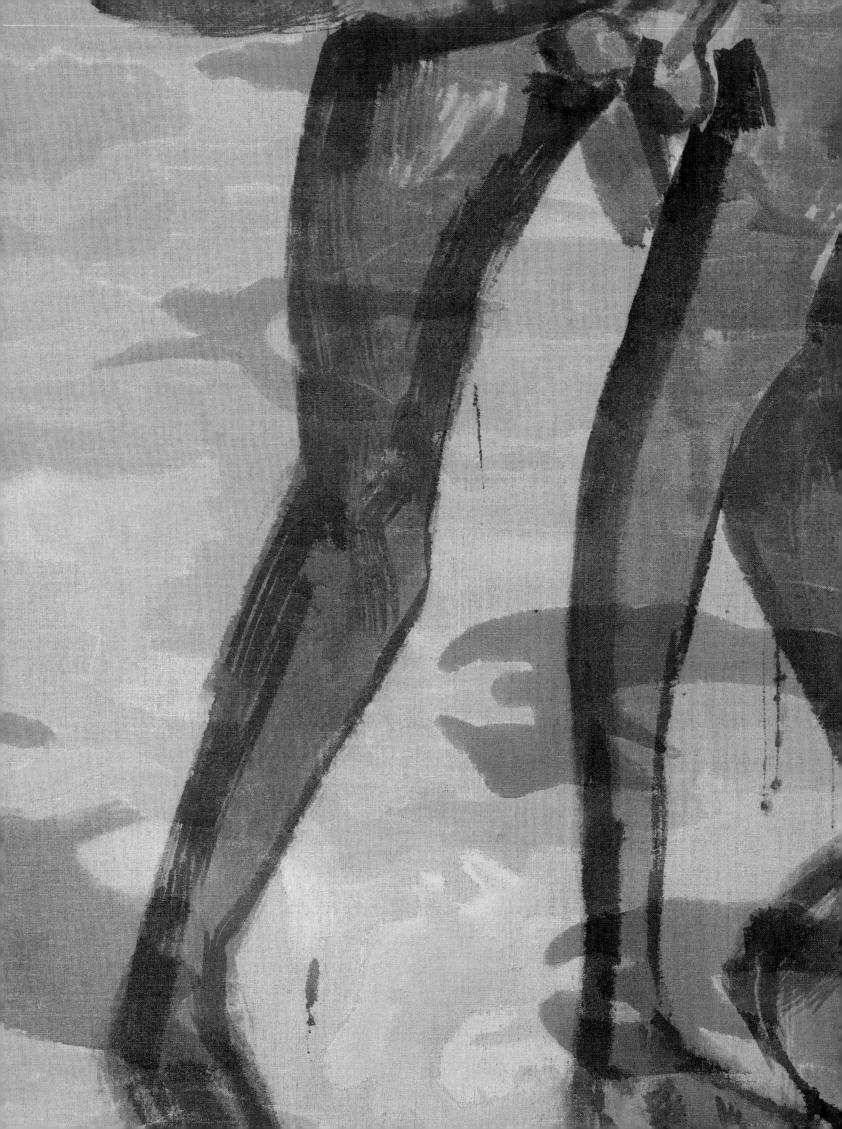

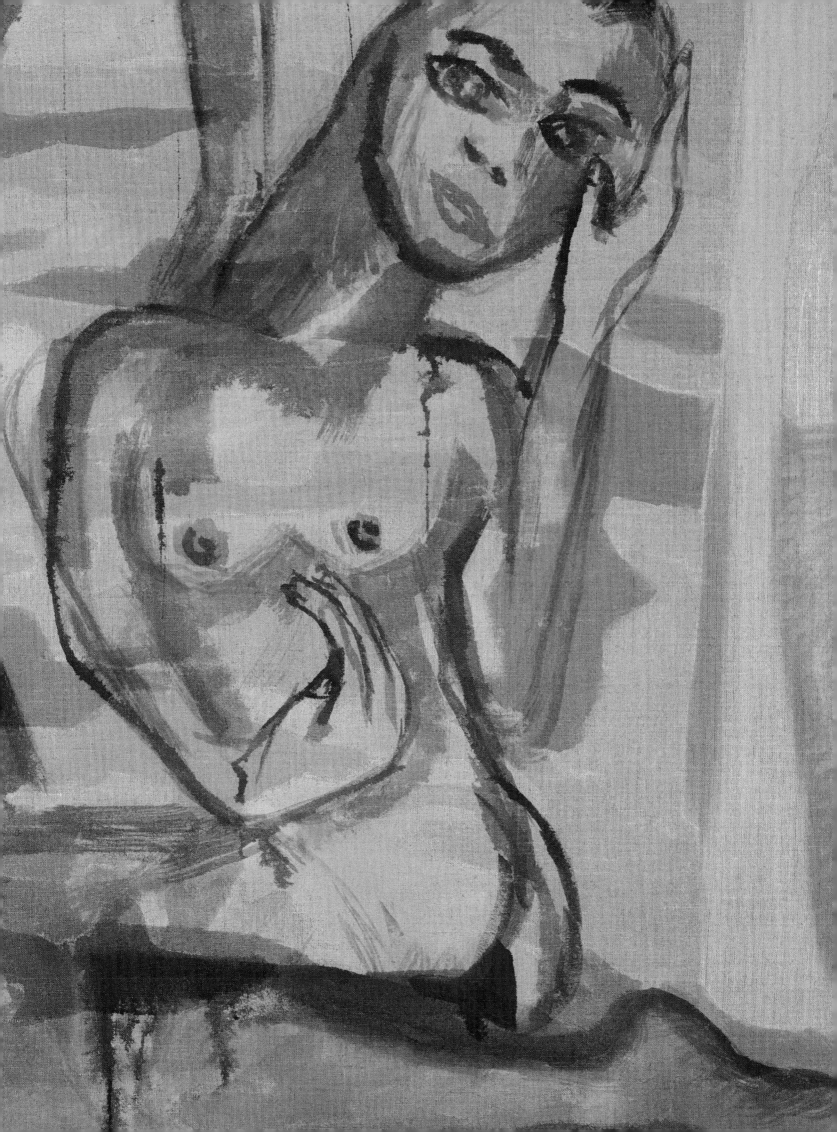

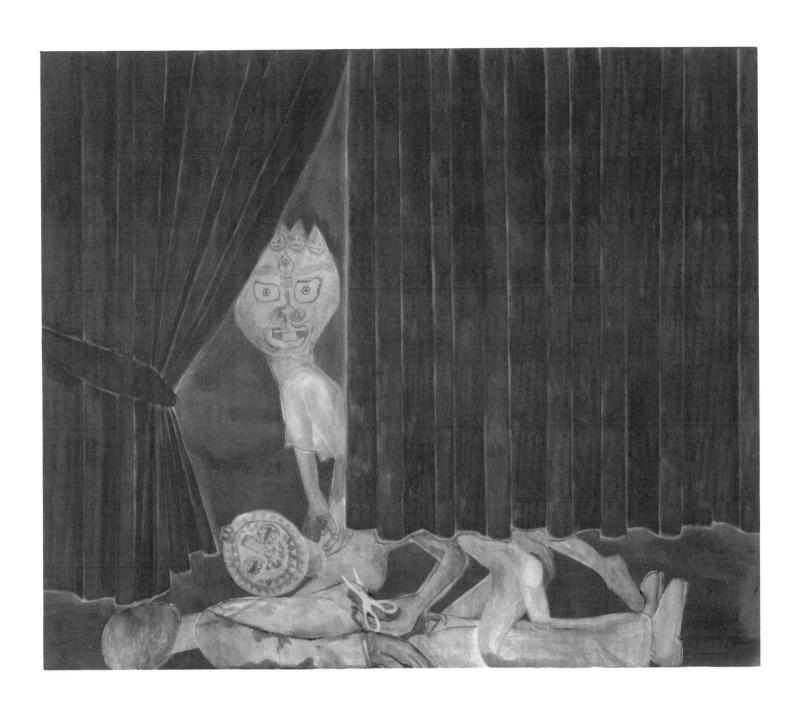

THE GOLDEN RULE
2012, oil and pigments on linen, 78 x 93 in

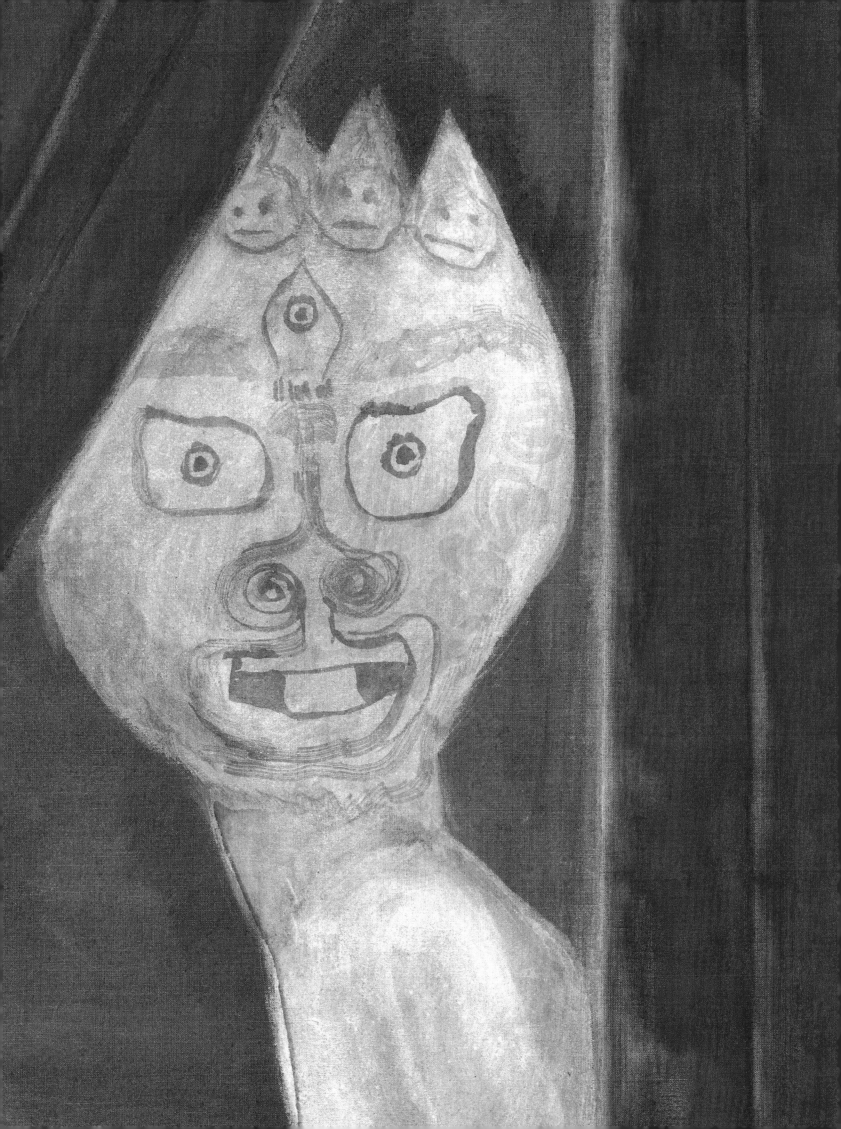

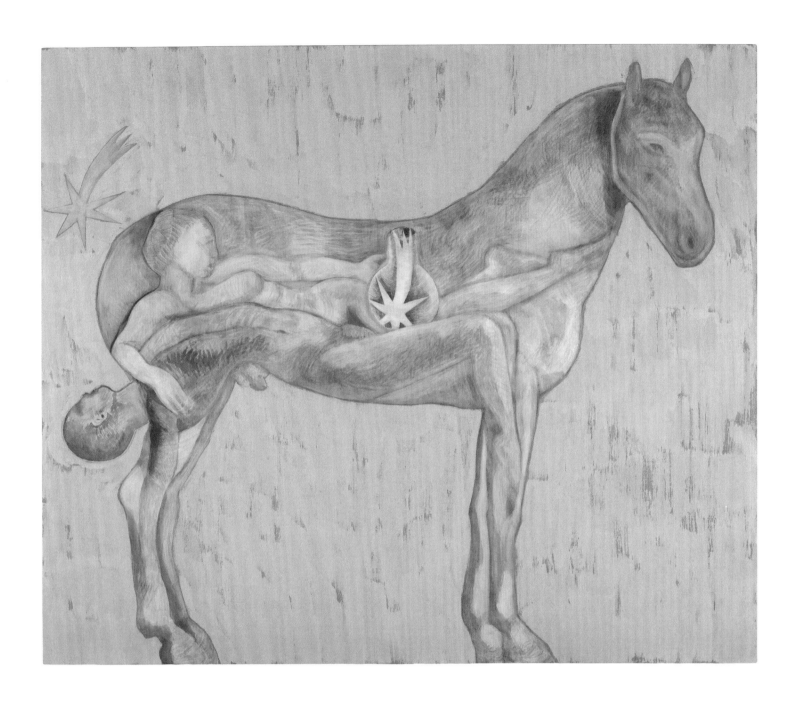

CHASING THE STAR

2012, pigments on linen, 78 x 93 in

53

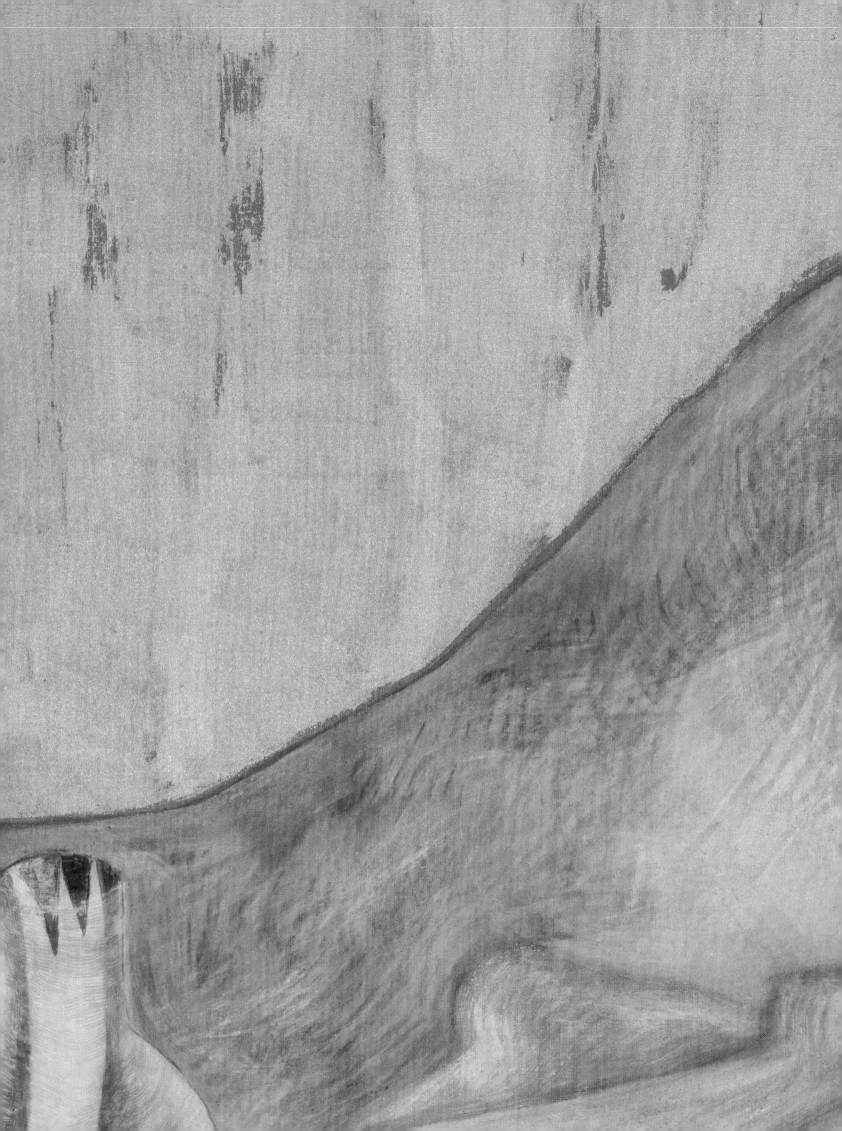

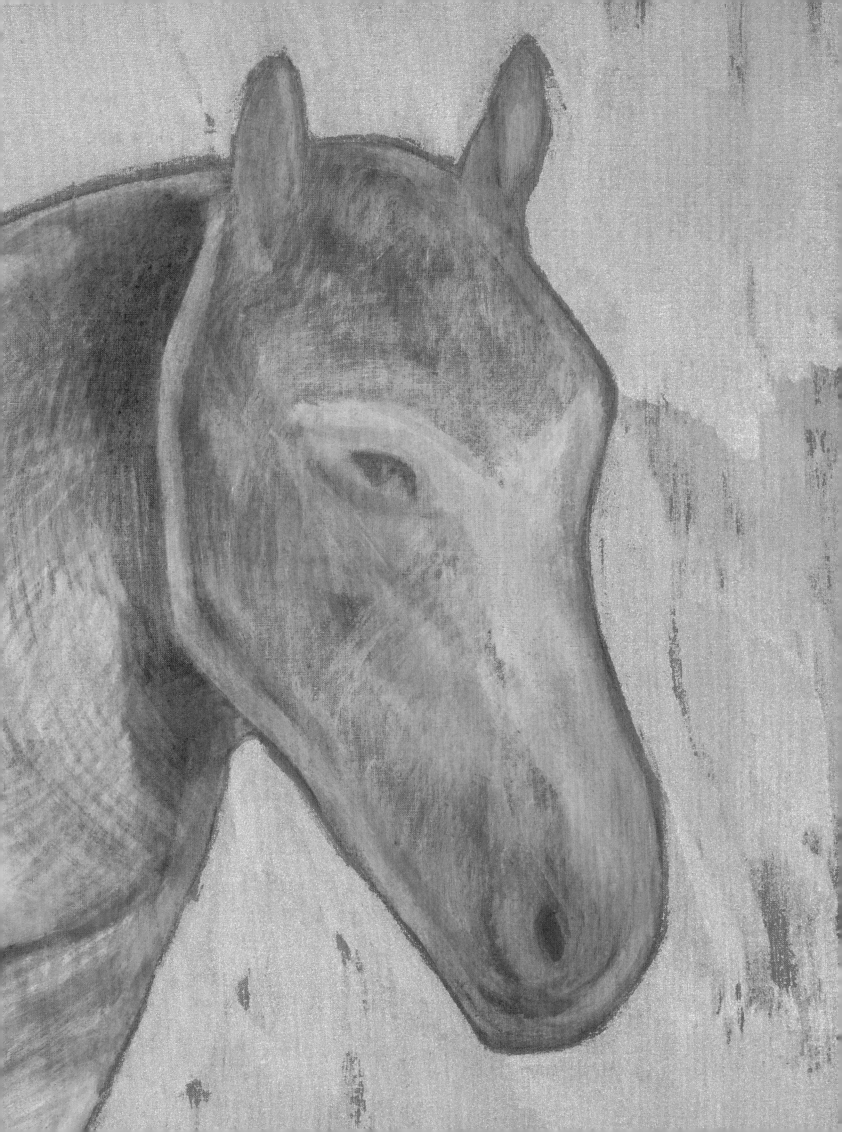

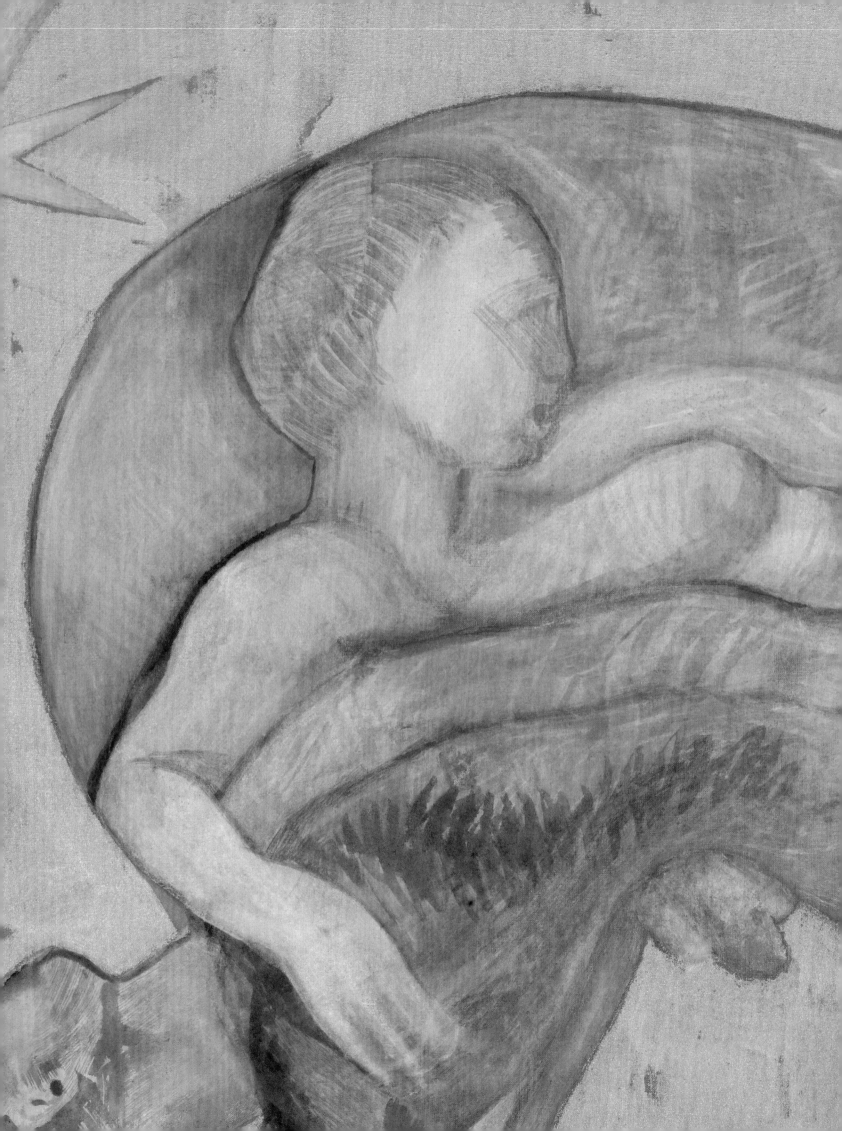

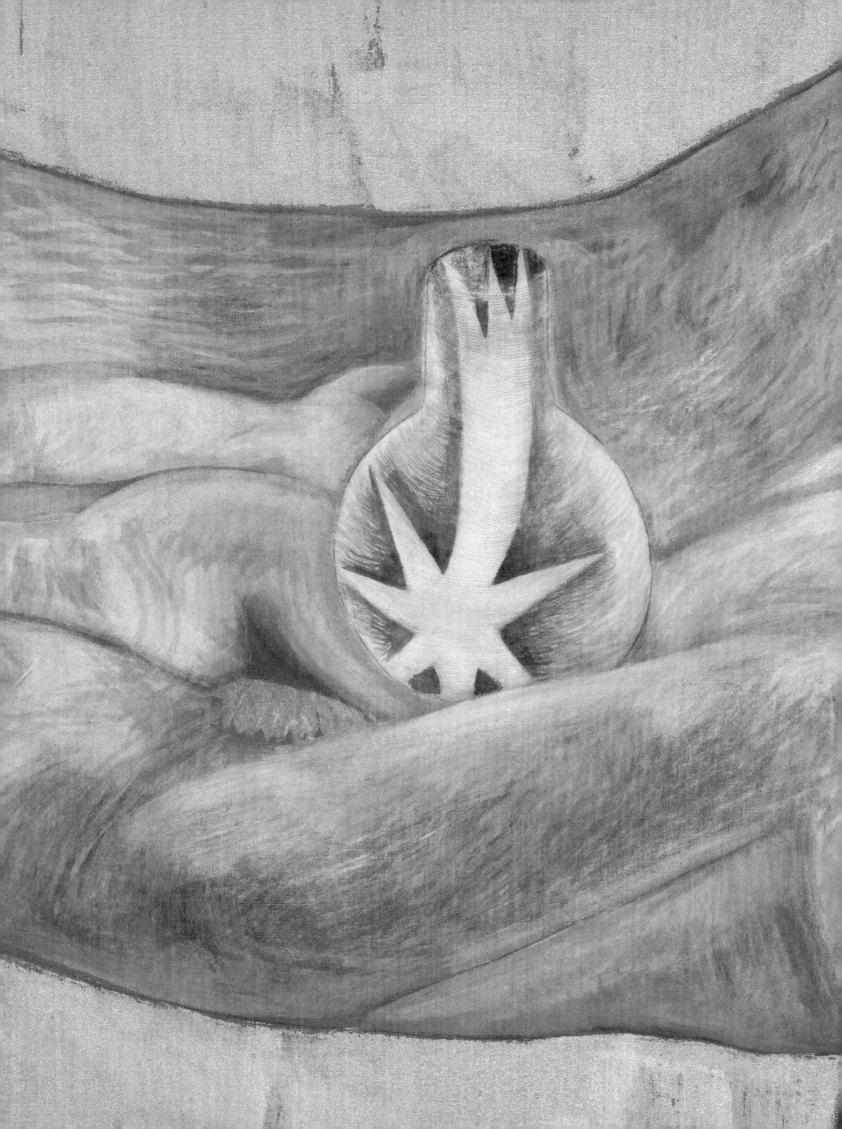

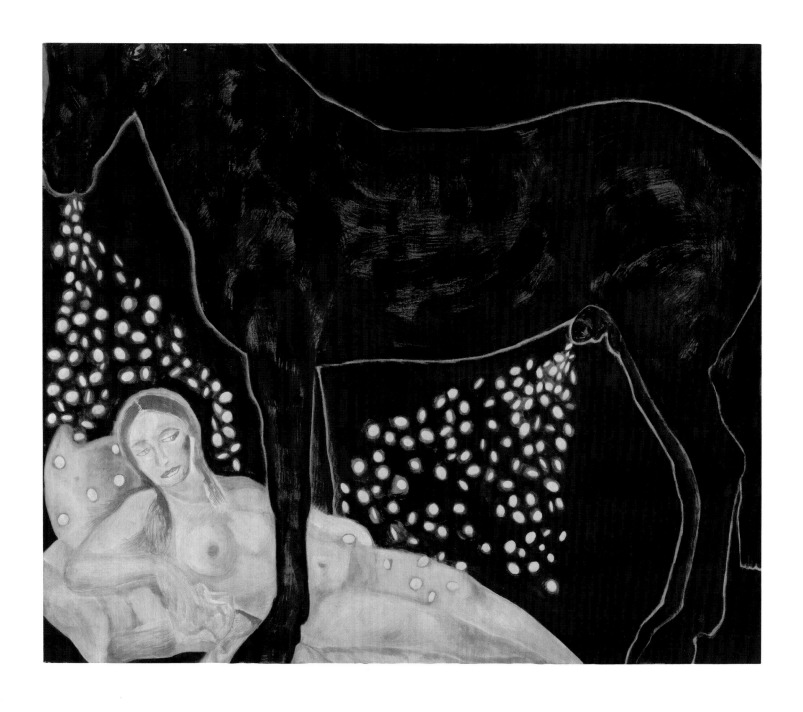

INDIGO'S CHILD
2012, pigments on linen, 78 x 93 in

59

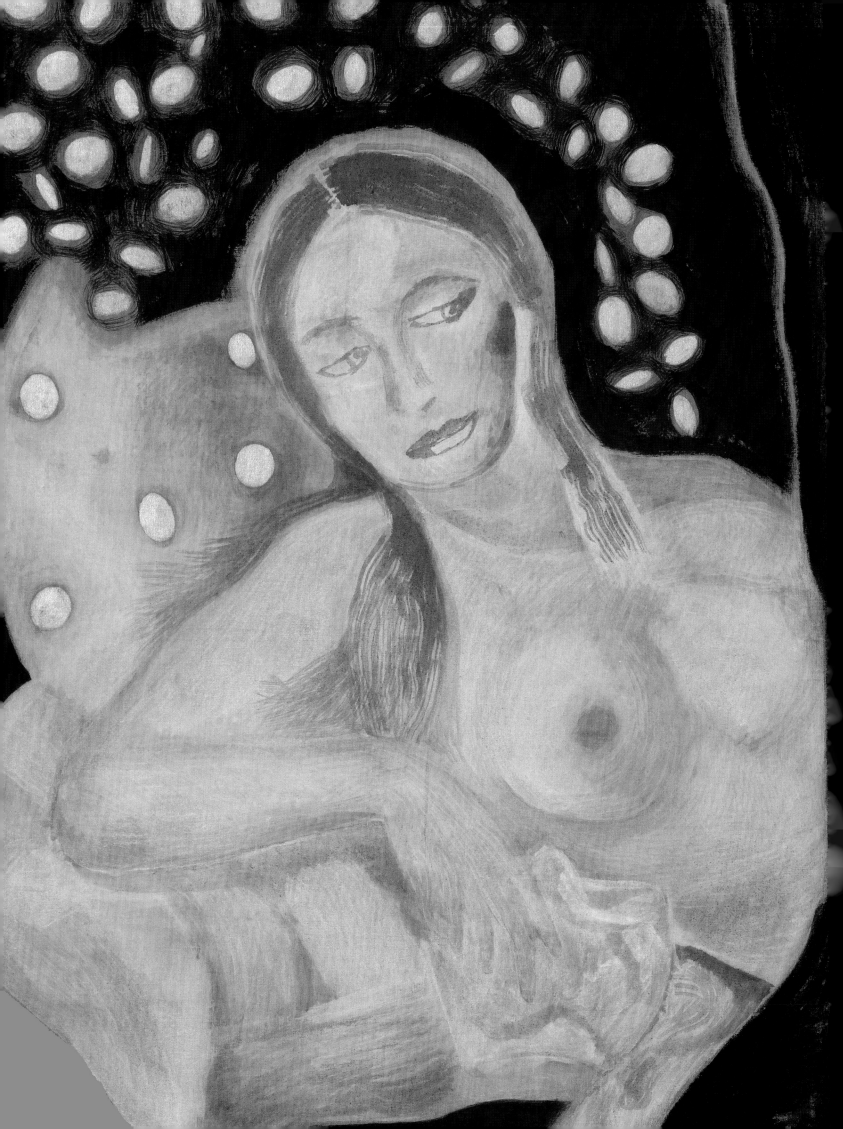

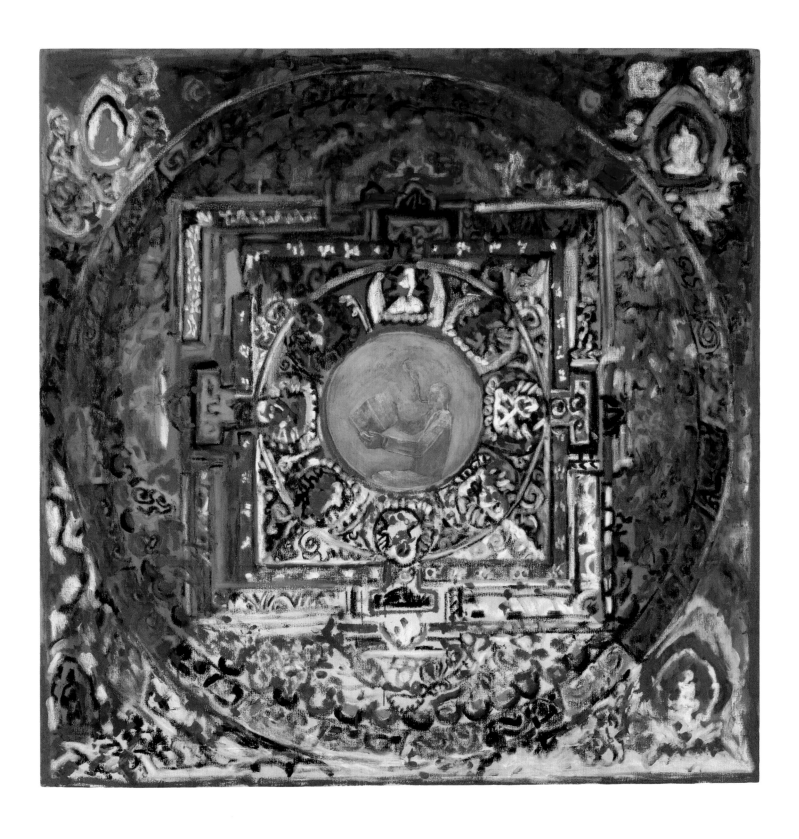

NEWSPAPER MANDALA
2012, oil and pigments on linen, 72 x 72 in

65

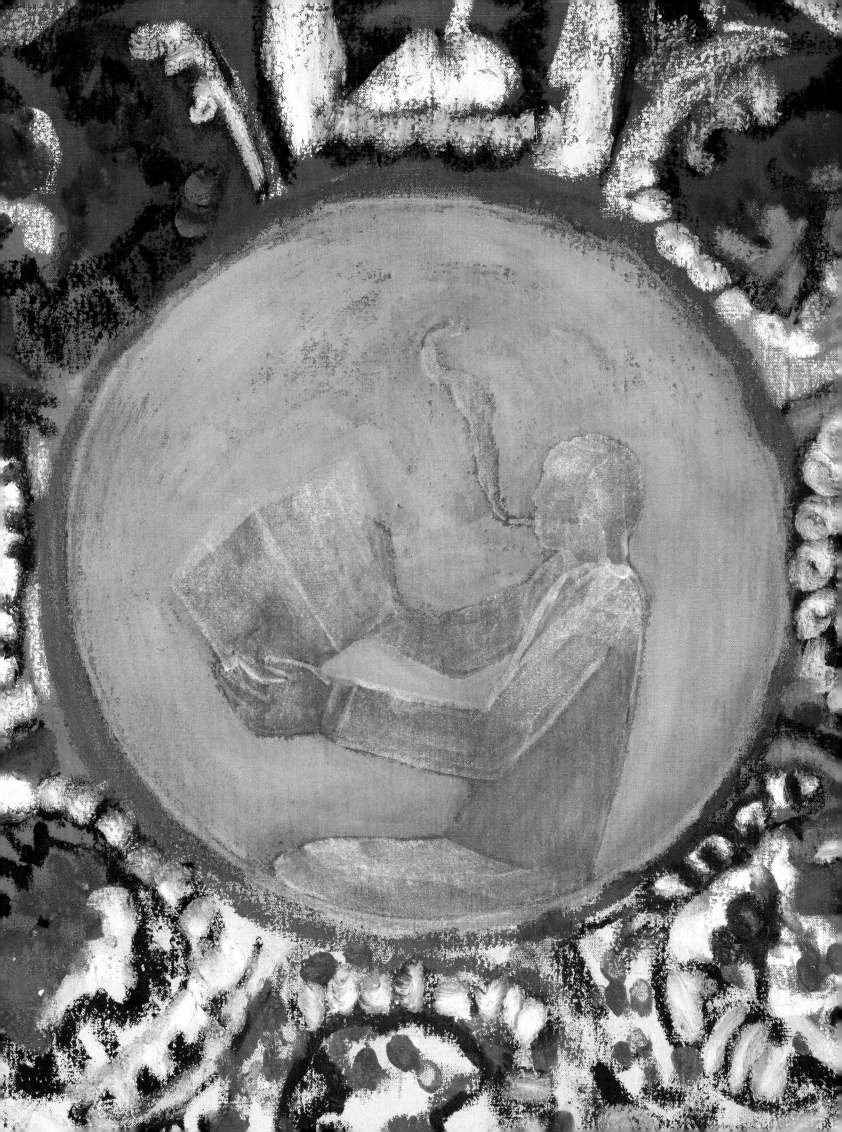

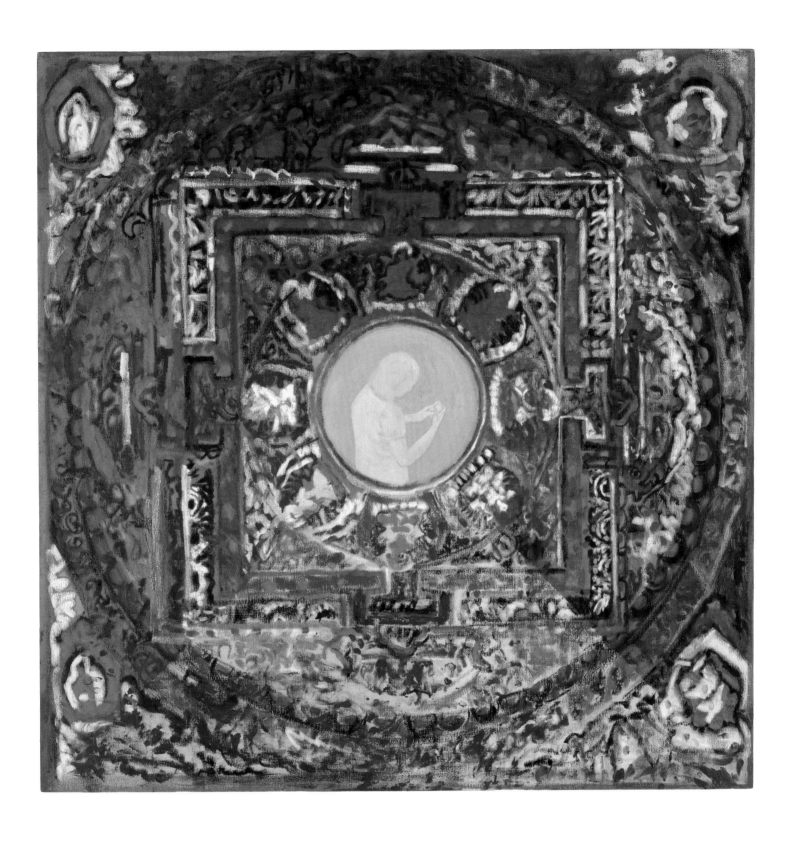

SAND BITES MANDALA
2012, oil and pigments on linen, 72 x 72 in

69

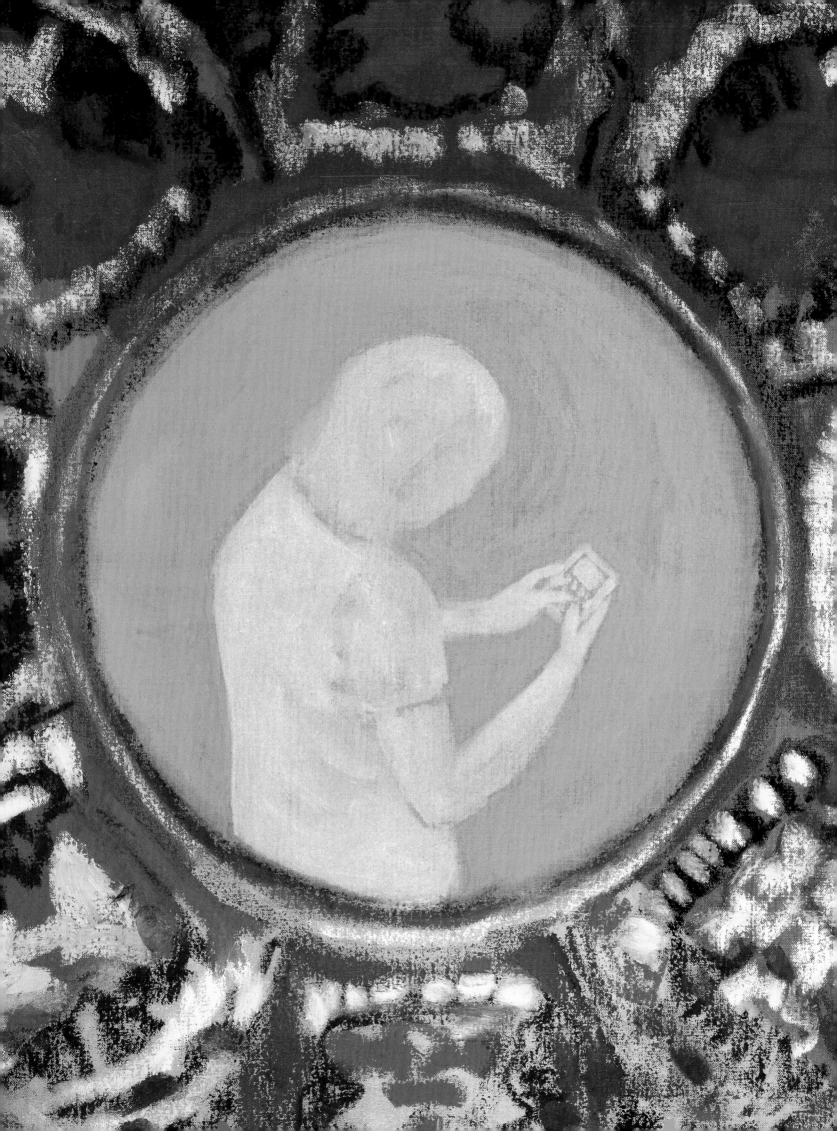

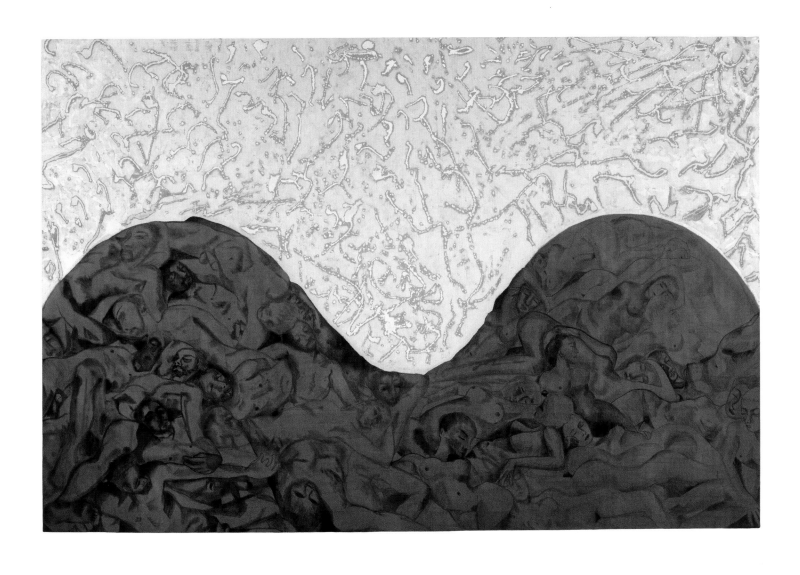

LA FEMME FONTAINE
2012, pigments on linen, 96 x 144 in

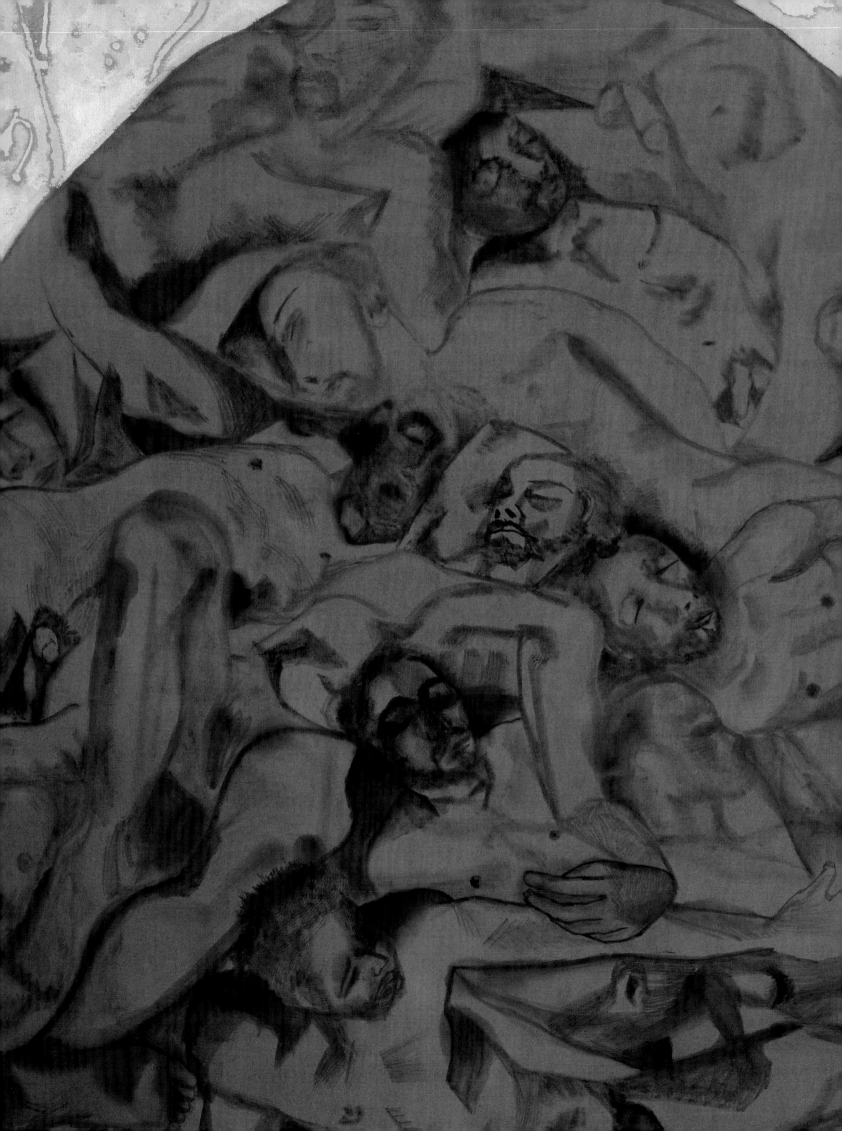

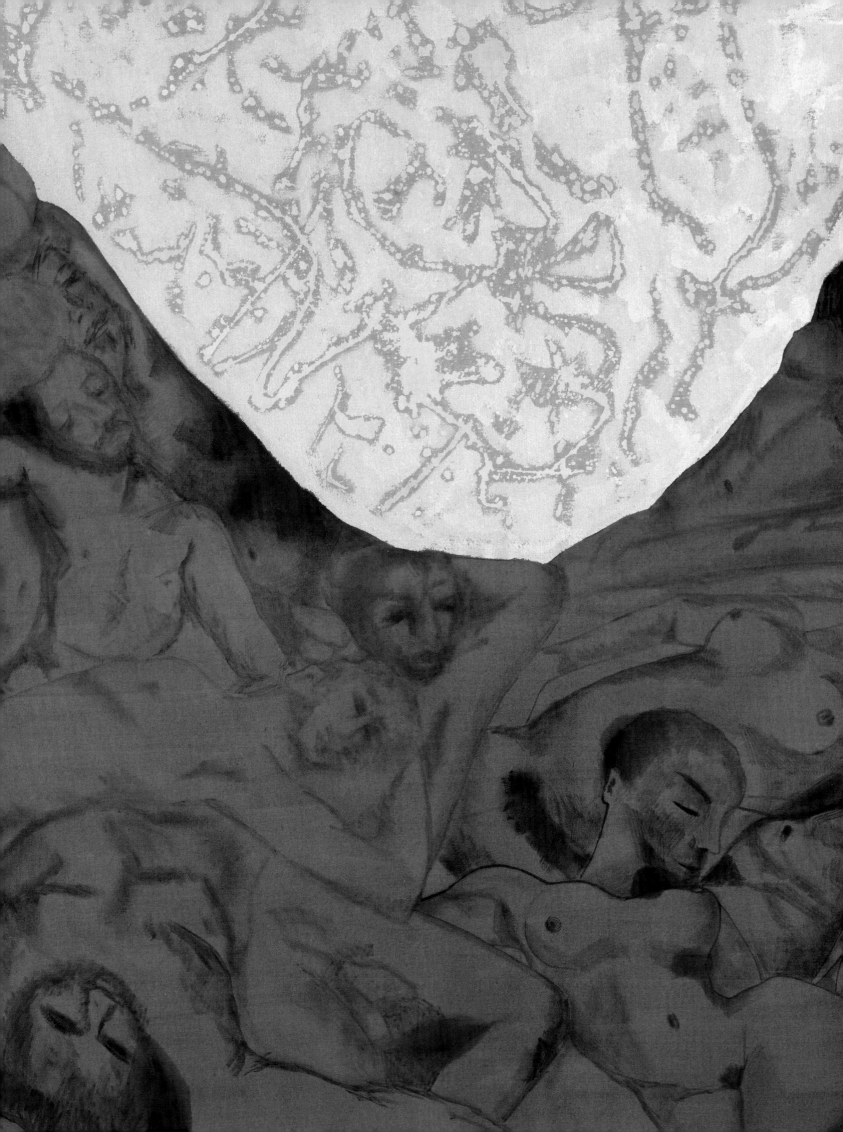

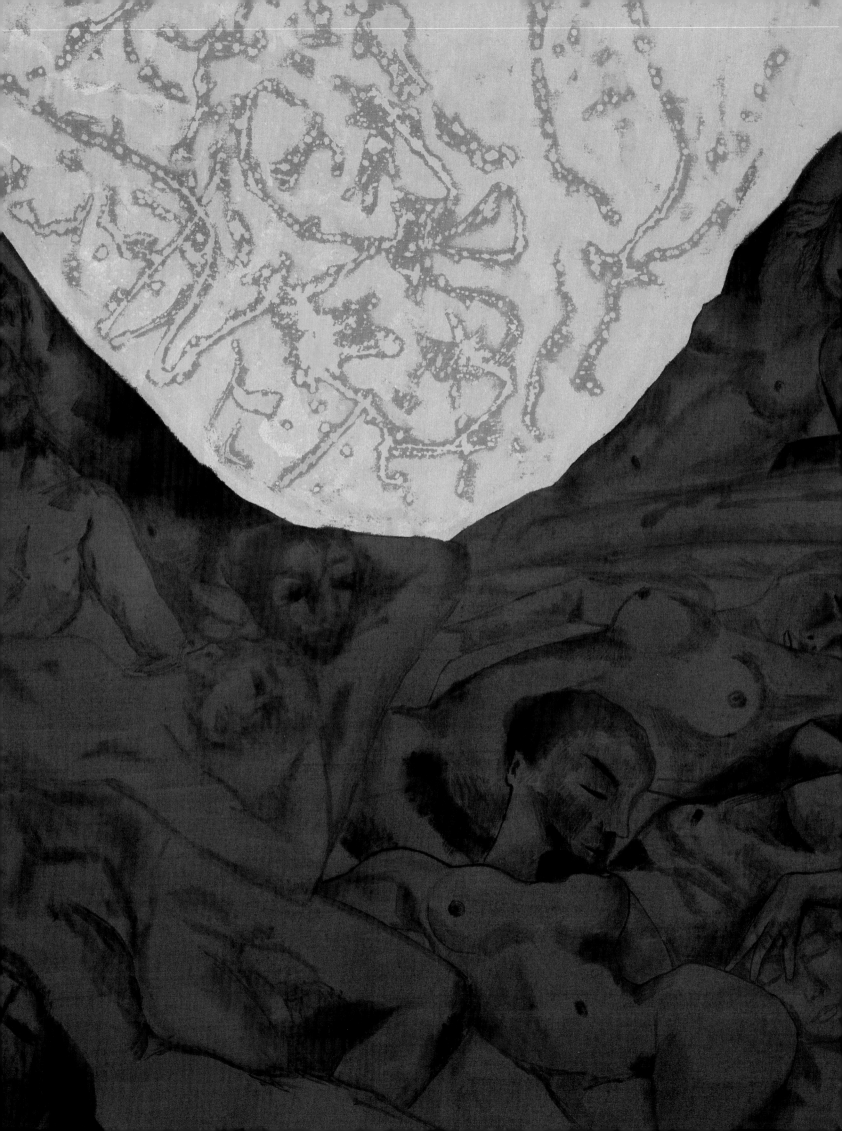

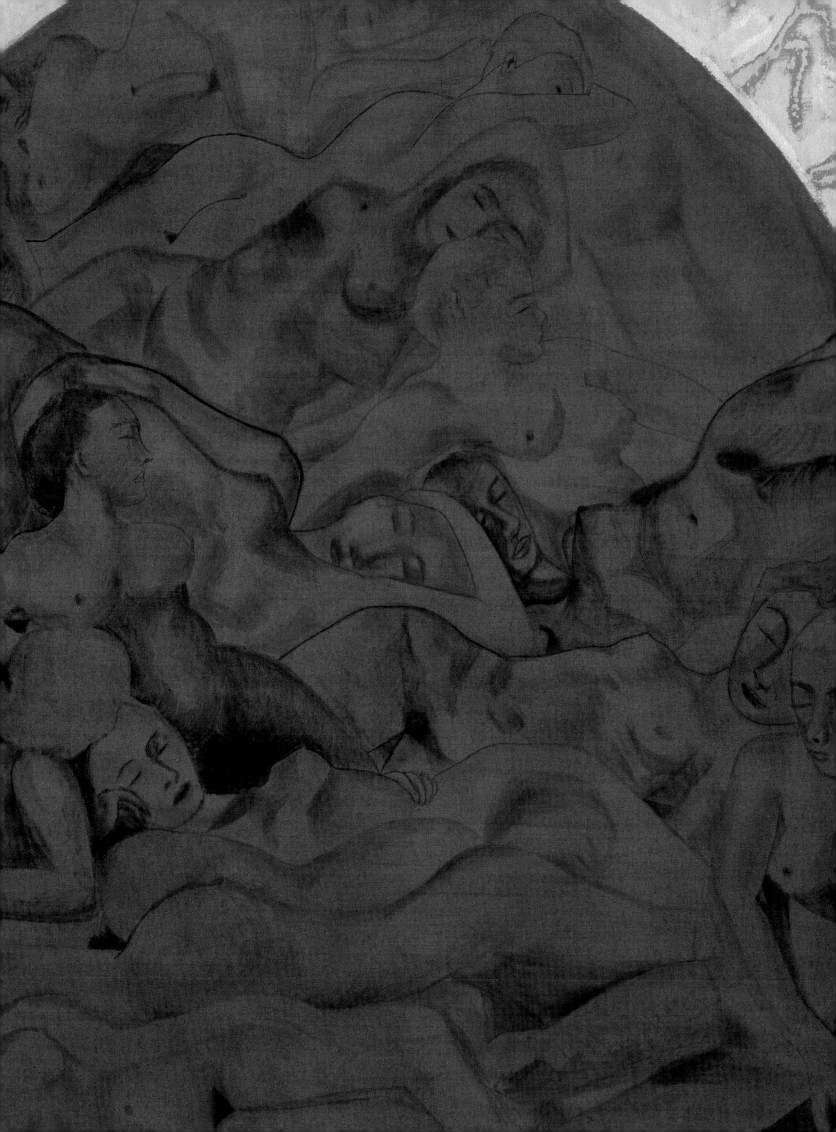

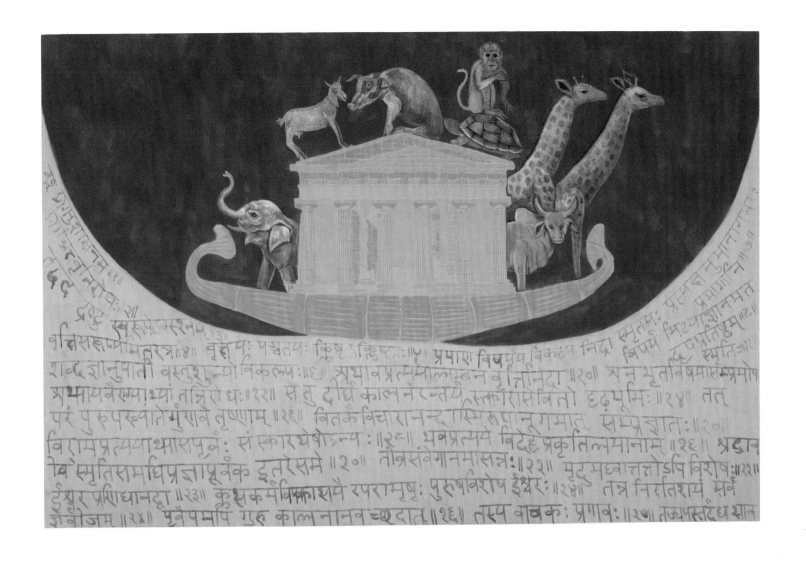

THE ARK
2012, pigments on linen, 96 x 144 in

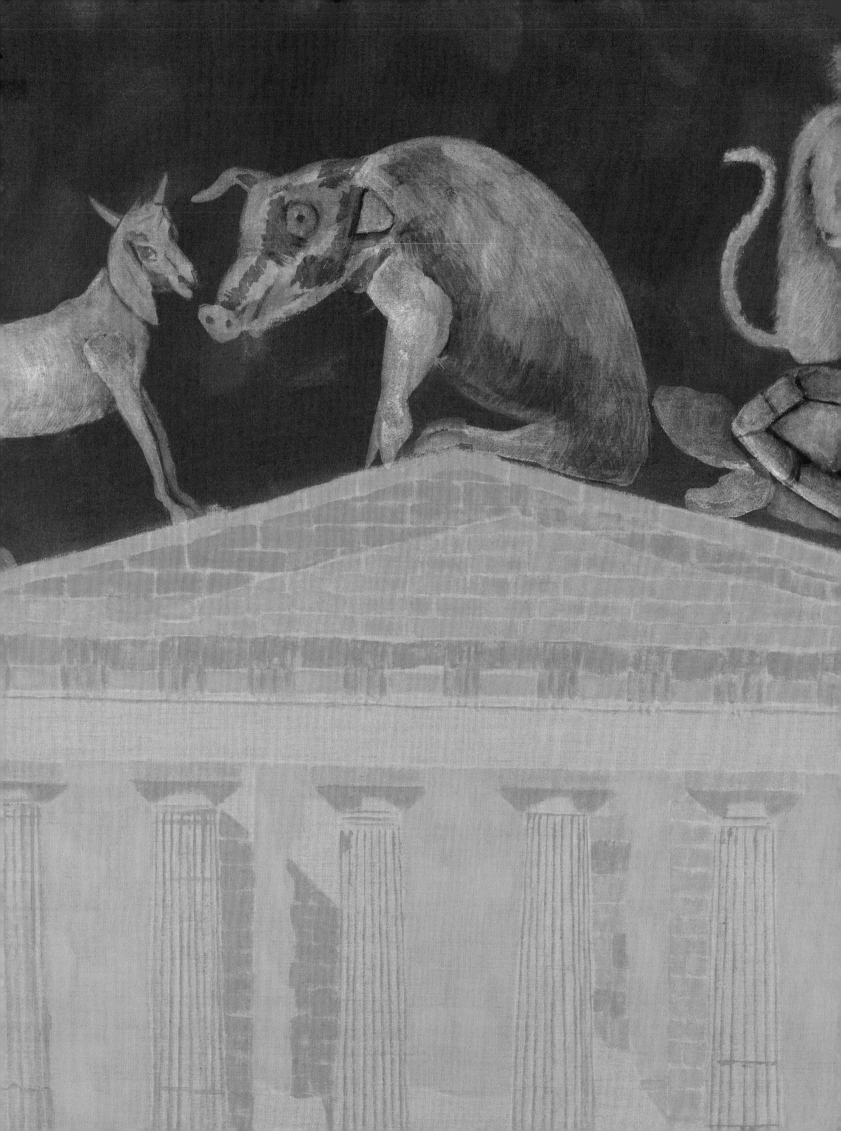

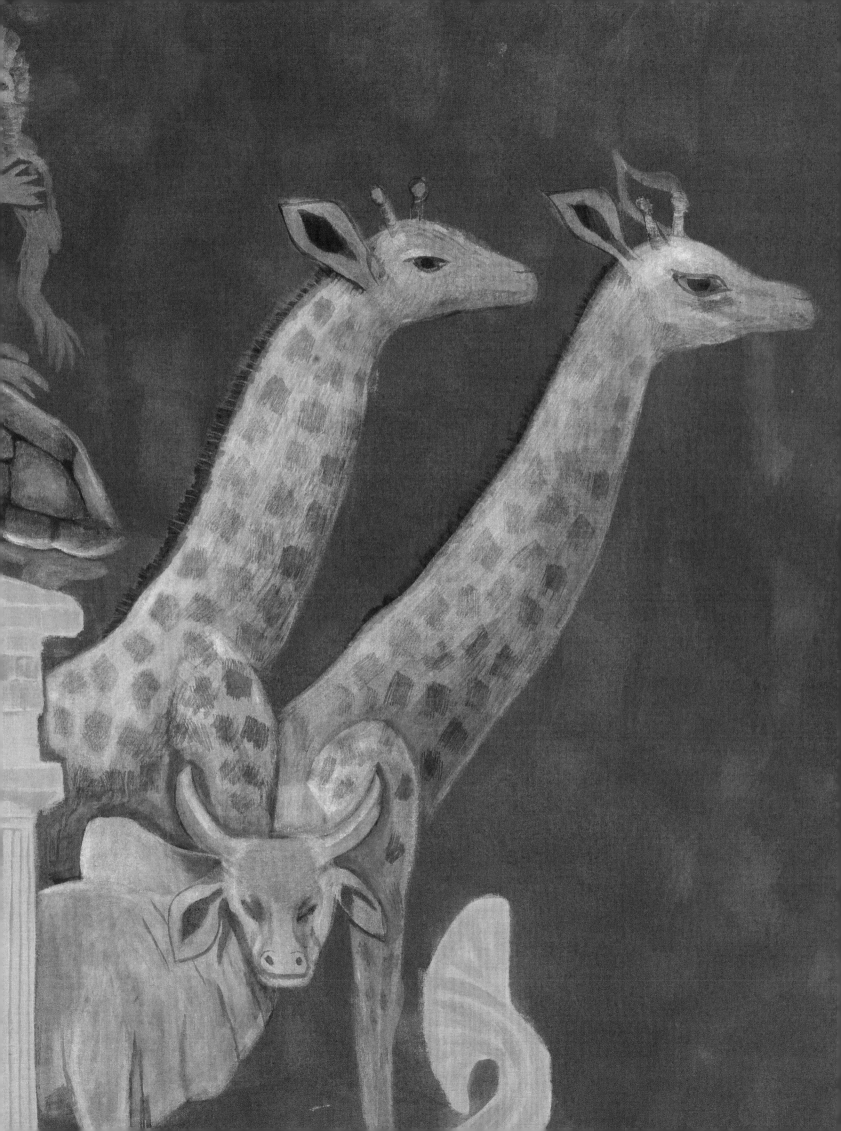

...प्य :||६|| त्राधावप्र...

...रात रोध काल...

...र।|| विरक विचा...

...रायोयोऽन्प :||२...

...रेरसमे ||२०|| तो...

...विकाशियें रपरा...

...काल नान्द च...

श्वप्रस्थे विरे

र्वे गान्गमरत्रः॥

पुरुषविरोश्च ईश्व

॥ ७६ ॥

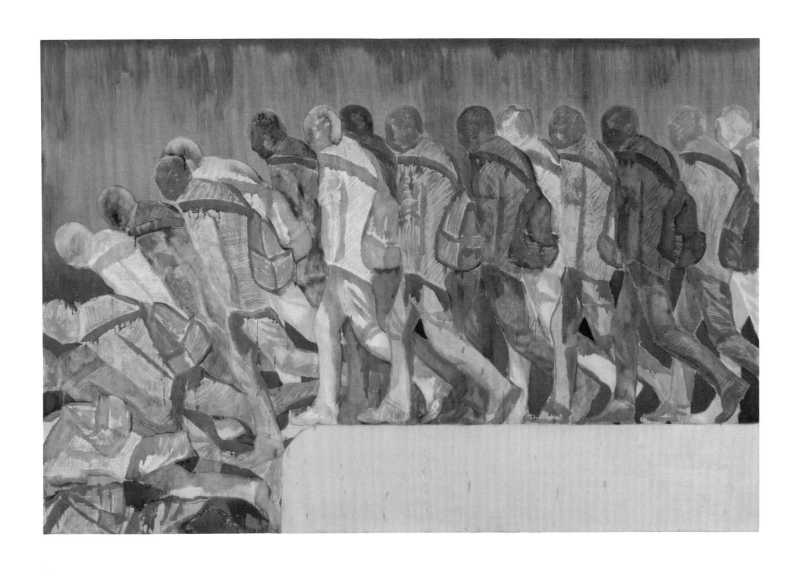

THE BACKPACKER

2012, pigments on linen, 96 x 144 in

85

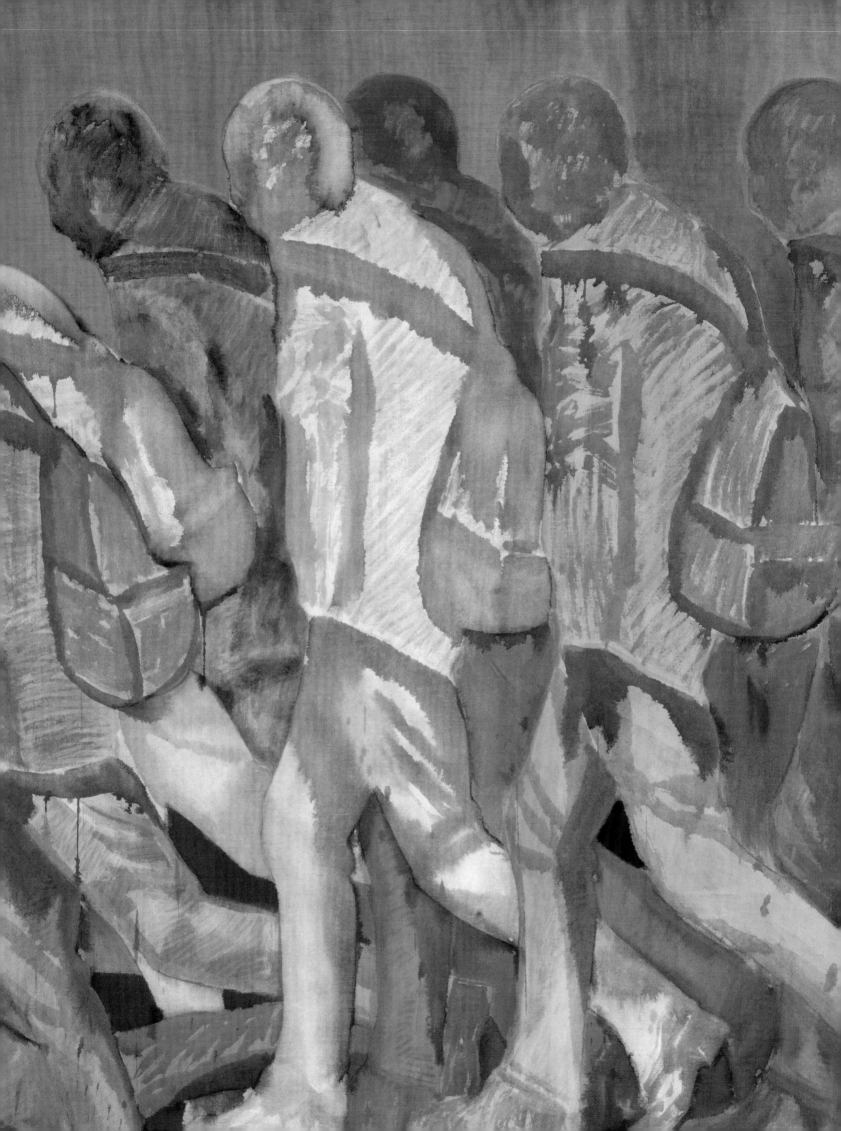

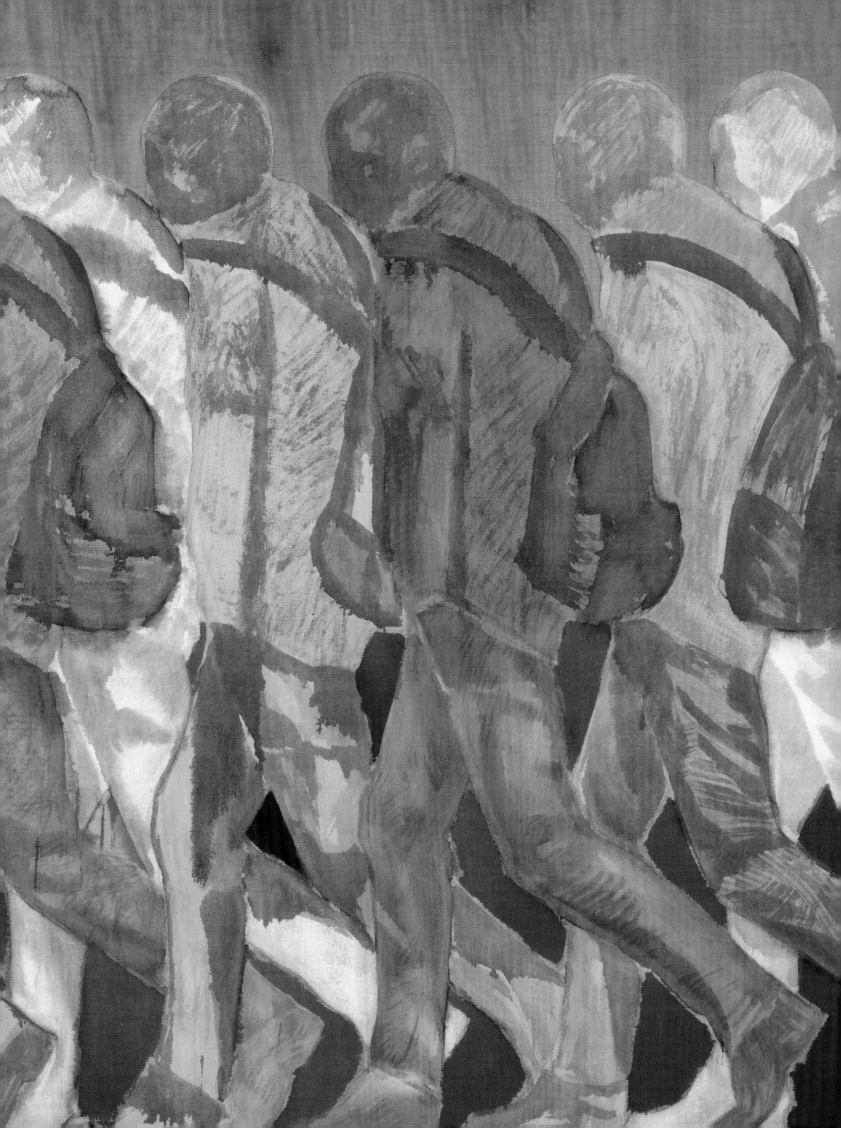

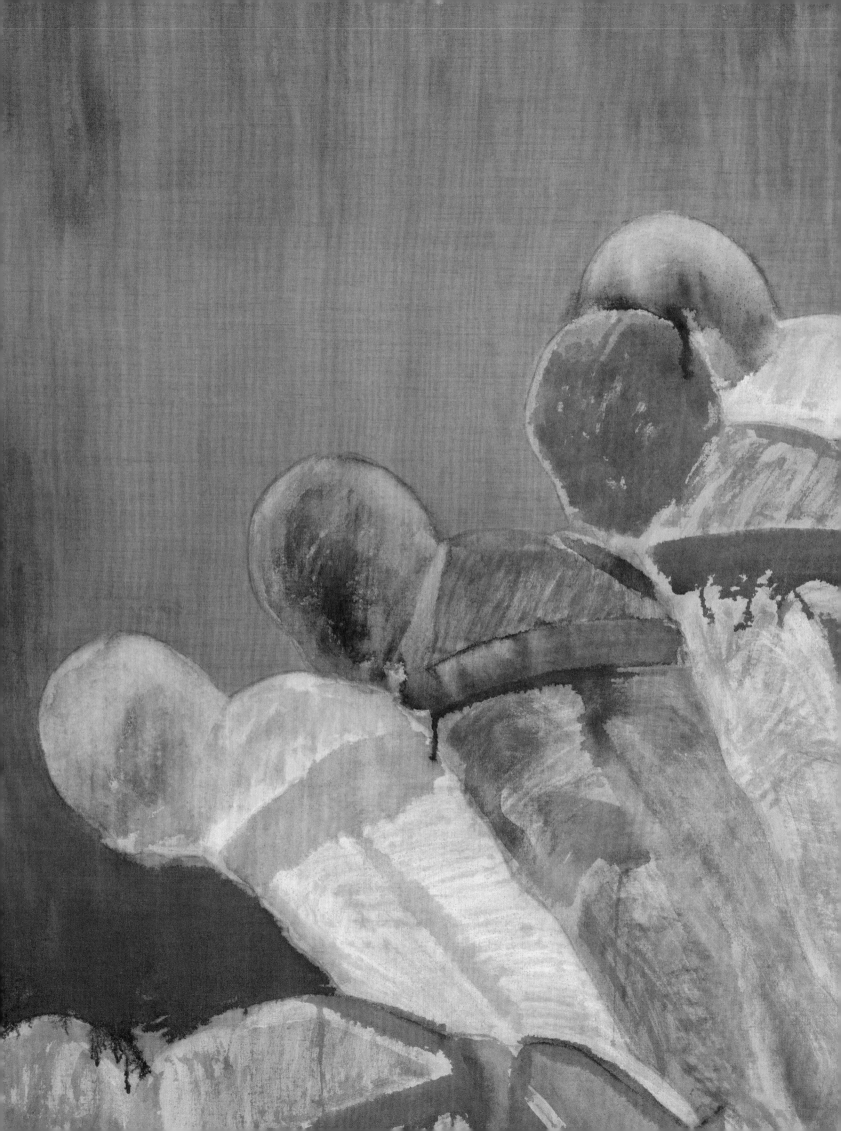

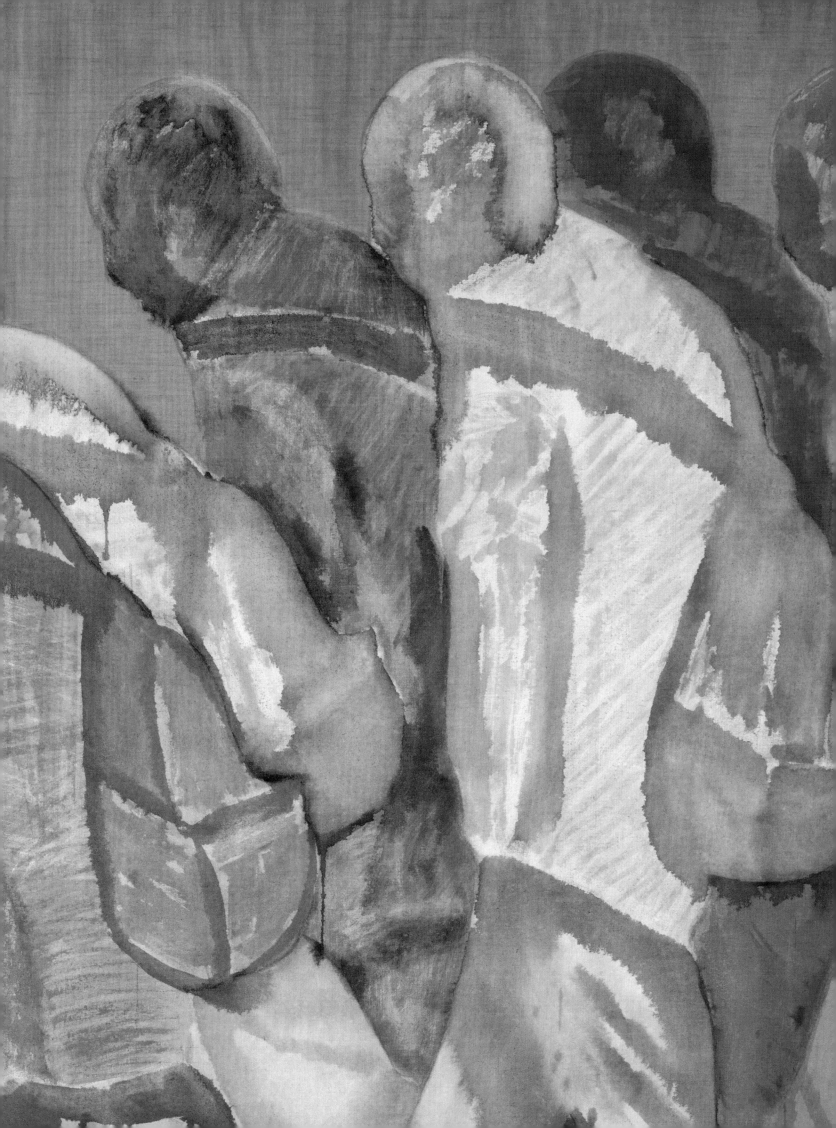

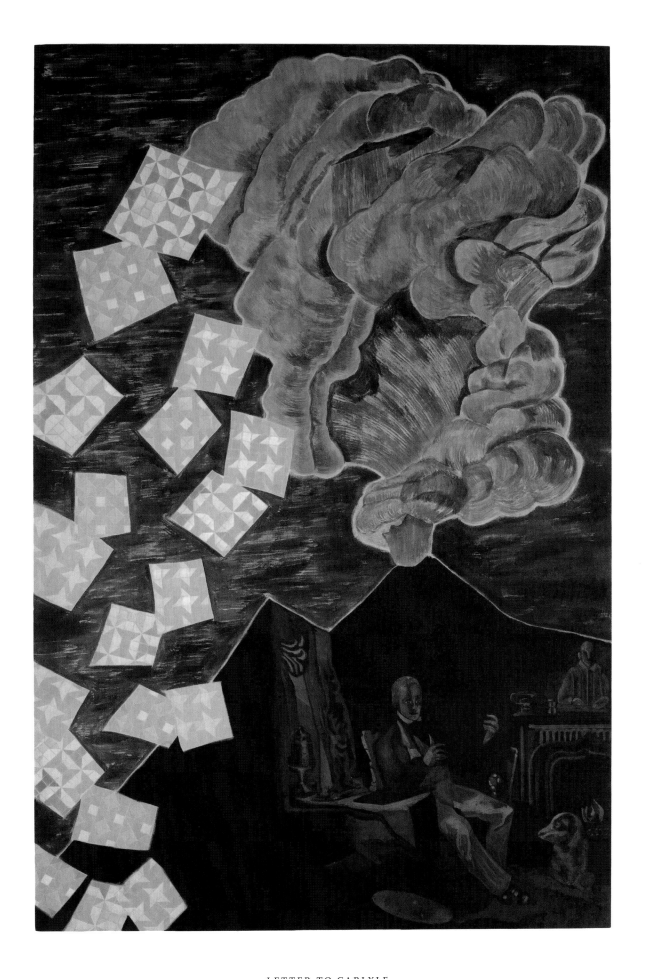

LETTER TO CARLYLE
2012, pigments on linen, 144 x 96 in

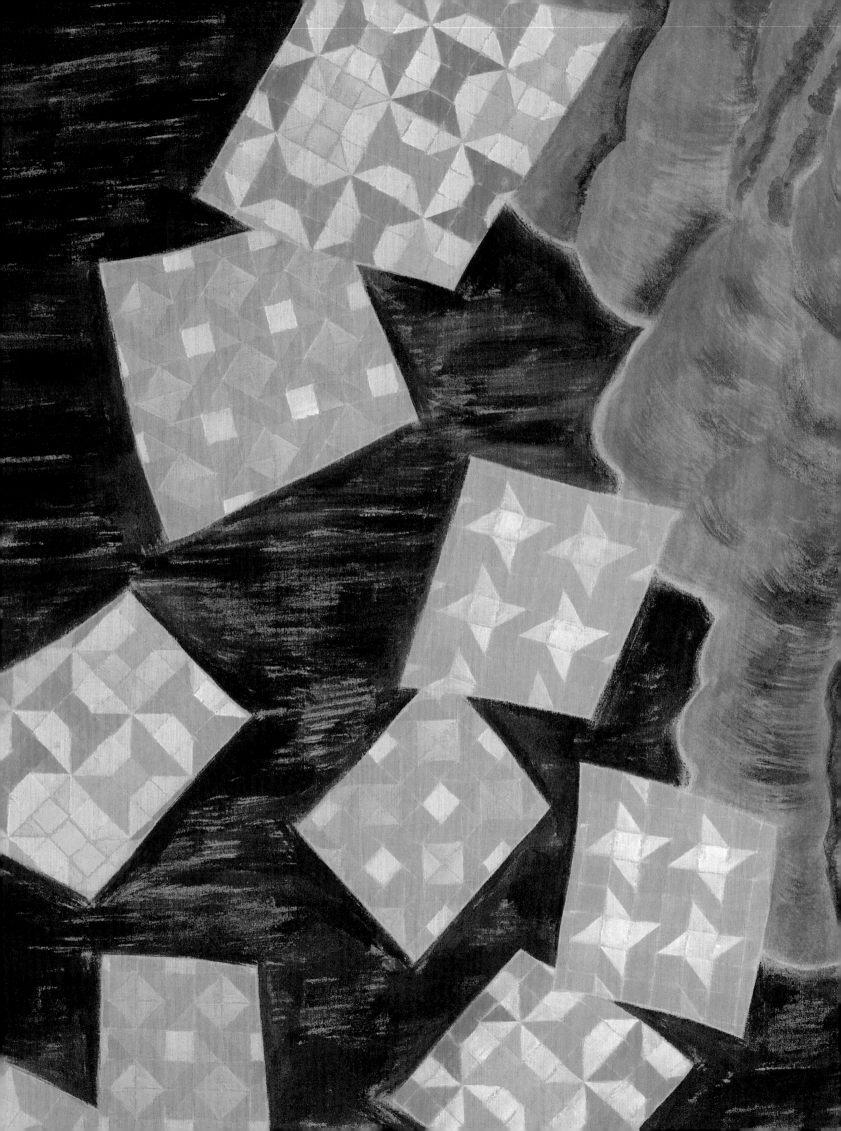

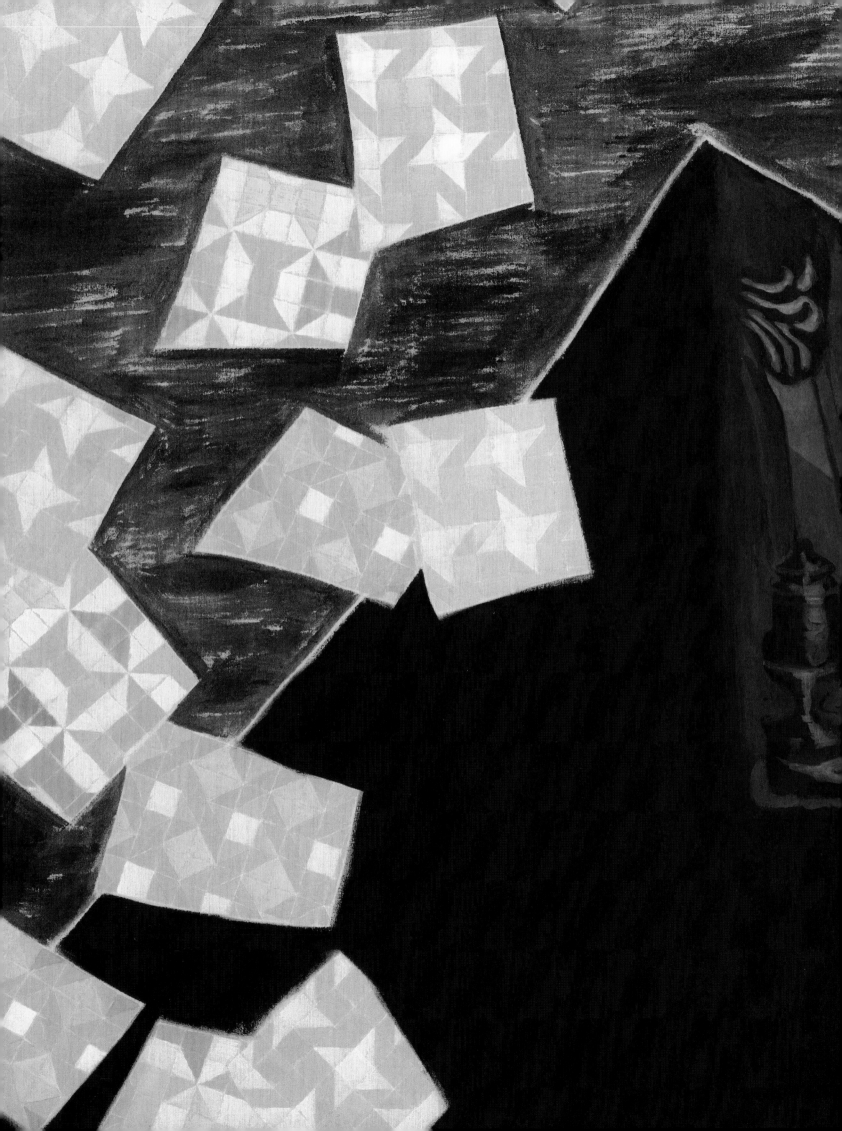

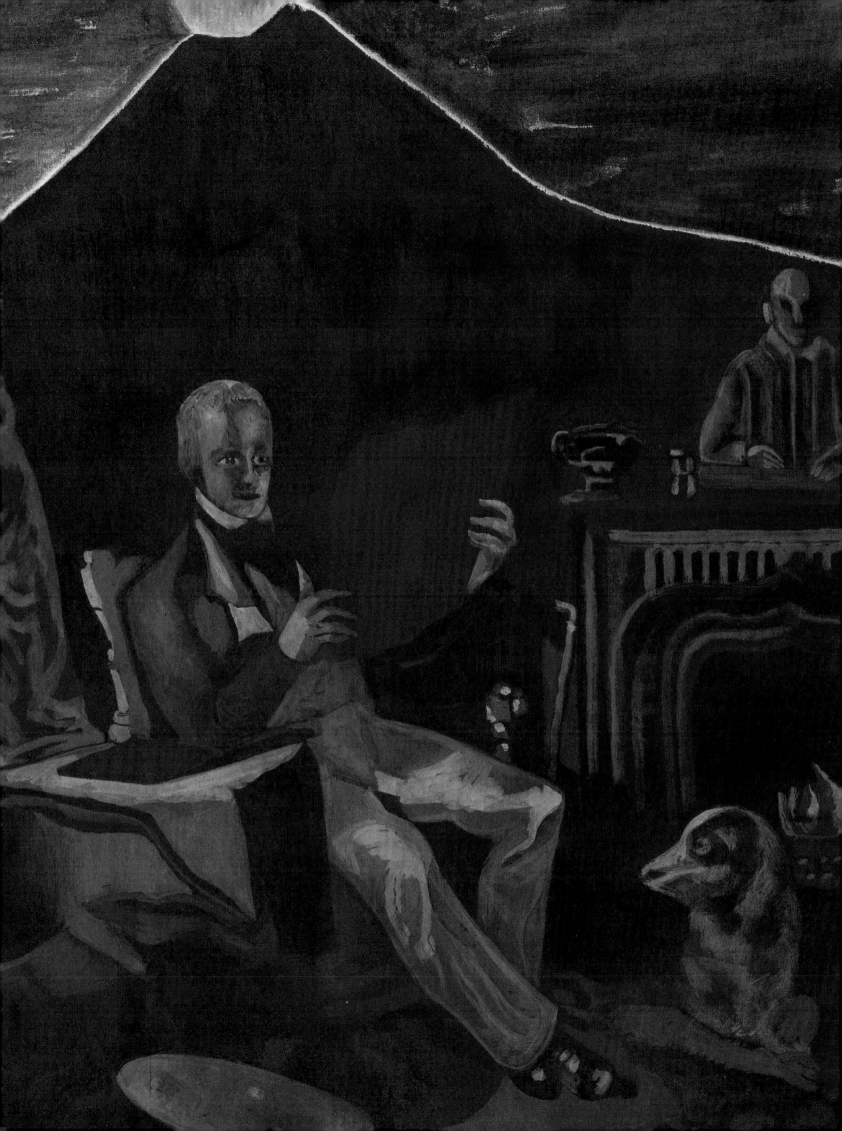

MANDALA FOR CRUSOE

INDEX OF WORKS

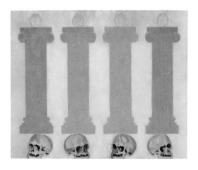

GANDHARA DREAM

2012

Pigments on linen

91 x 112 in / 231.1 x 284.5 cm

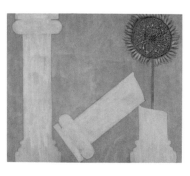

THE TRIUMPH OF THE SUNFLOWER

2012

Pigments on linen

91 x 112 in / 231.1 x 284.5 cm

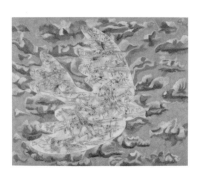

THE DOVE OF WAR

2012

Pigments on linen

91 x 112 in / 231.1 x 284.5 cm

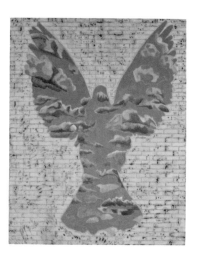

THE SKY ON THE WALL

2012

Pigments on linen

112 x 91 in / 284.5 x 231.1 cm

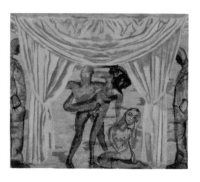

CANDY AND CHLOE AT THE GATE

2012

Pigments on linen

78 x 93 in / 198.1 x 236.2 cm

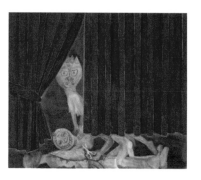

THE GOLDEN RULE

2012

Oil and pigments on linen

78 x 93 in / 198.1 x 236.2 cm

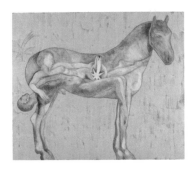

CHASING THE STAR
2012
Pigments on linen
78 x 93 in / 198.1 x 236.2 cm

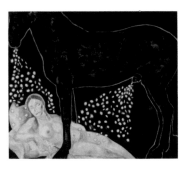

INDIGO'S CHILD
2012
Pigments on linen
78 x 93 in / 198.1 x 236.2 cm

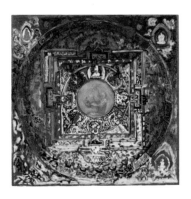

NEWSPAPER MANDALA
2012
Oil and pigments on linen
72 x 72 in / 182.9 x 182.9 cm

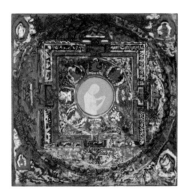

SAND BITES MANDALA
2012
Oil and pigments on linen
72 x 72 in / 182.9 x 182.9 cm

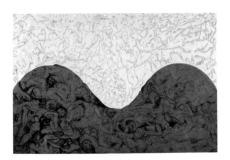

LA FEMME FONTAINE
2012
Pigments on linen
96 x 144 in / 243.8 x 365.8 cm

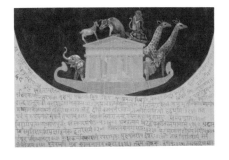

THE ARK
2012
Pigments on linen
96 x 144 in / 243.8 x 365.8 cm

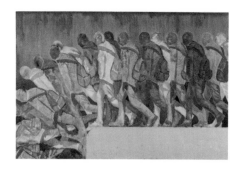

THE BACKPACKER

2012
Pigments on linen
96 x 144 in / 243.8 x 365.8 cm

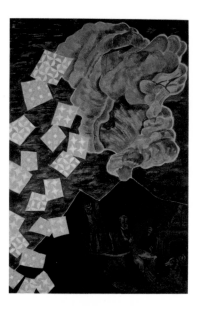

LETTER TO CARLYLE

2012
Pigments on linen
144 x 96 in / 365.8 x 243.8 cm

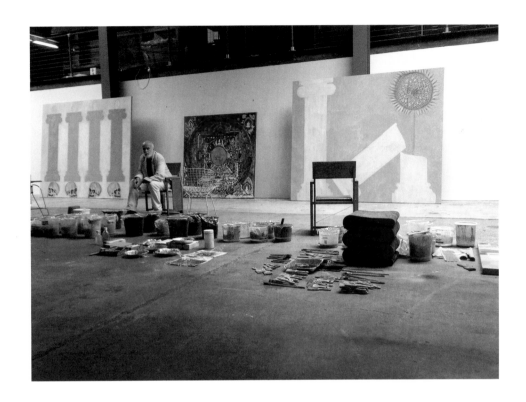

Francesco Clemente, Brooklyn, New York, 2012
Photograph by Mario Codognato